# Through THICK & THIN

### The Terri Lipsey Story

Terri Lipsey
with Dr. Dick Newman

### The Terri Lipsey Story

Terri Lipsey
with Dr. Dick Newman

River City Press, Inc.
*Life Changing Books*

Through Thick and Thin
The Terri Lipsey Story
Copyright 2006, Terri Lipsey
Broomfield, CO—All Rights Reserved

No part of this book may be reproduced in any manner without the written permission of the Publisher.

ISBN No. 0-9776713-2-1

COVER DESIGN
Jennell Bandstra
Minneapolis, MN

GRAPHIC LAYOUT
Sara Jo Johnson
Roseville, MN

PUBLISHER
River City Press, Inc.
4301 Emerson Avenue North
Minneapolis, MN 55412
1-888-234-3559
www.rivercitypress.net

## *Dedication*

I dedicate this book, first of all, to my darling husband, Cedric. You have always helped me feel like a complete woman, even when I weighed 300 pounds. Your gentle spirit and your loving support have been the catalysts that carried me through my darkest hours of pain and depression.

I will be forever grateful to you, not for what you have done, but for who you are: my husband, confidant, soul mate, lover and spiritual leader.

You are my knight in shining armor!

To momma's baby, LéVertis, I am so proud of the strong, intelligent, giving young man you have turned out to be. I have learned so much from you. Thank you for your honesty and loving spirit. Being your mom means that I have been given one of life's greatest gifts—you! Ahhh humm!

To my awesome mother, you have played such a major role in my life. You are my star. I admire your strength, courage, and your wisdom. You are a powerful woman, and I aspire to walk in your footsteps. You have always been there for me. You've taught me how to be a strong woman and that there is nothing in this world that can stop me with God on my side. There

have been many great women, but you surpass them all, for you are my leading lady. Thanks Mom!

To my dad, you have given me so much to be thankful for. Thank you for being a provider and the foundation for our family. Anyone can steer a ship, dad, but it takes a leader to chart the course. I am so grateful you were that courageous leader!

Thank you, mom and dad. You raised me to be a hard worker and of strong moral character. I learned more than you can imagine from watching the two of you.

Thanks for teaching me that the world doesn't owe me anything and that nothing is automatic. I have to make it happen!

I had no say in where nor to whom I was born, but if I could'a I would'a and it would have been to the both of you.

To my sister, Teresa, your presence is a gift to the world. You are unique and one-of-a-kind! You have a sweetness that goes beyond your beautiful smile and a heart of pure gold. I admire your personality, character and the qualities you possess. You will forever be the greatest big sister on this planet and my best friend!

To my hero, Carlton, thank you for believing in me and never giving up on me. Do you think I can still make the Olympic try-outs? You are the best man!

To Michael Snyder, MD, FACS, PC, for your dedication to helping people embark on a new and exciting lifestyle. Without your skill and your devotion to improving the quality of life for your patients I would not be where I am today.

Last of all, I dedicate this book to Oprah Winfrey! I learned about gastric bypass surgery while watching your show.

Thank you for reaching out to a tired, heartsick, suffering, overweight—terribly overweight—young woman. Your show made me aware of a viable solution.

I can't begin to tell you how much I love and appreciate you for what you have done for me personally and for my family. You are an angel dressed up in human clothing!

# Acknowledgements

To Dr. Dick Newman, thank you for working tireless hours, day and night, to help write my story in a way that I believe will touch many lives. You are an amazing writer and an amazing person. Your wisdom and guidance have been much appreciated.

To Jenny Newman, thank you for supporting this project. I know I took Dr. D. away for a lot of hours.

To my publisher and editor, Bob Wolf, thank you for your hard work and dedication to see that my story gets told.

To Dolly and Brandi, thank you for your invaluable support to my mom and me; you helped to make it happen.

To Mr. and Mrs. Johnstone, thank you for all the cans of Slim-Fast you bought me in High School.

To all my friends who never judged me because of my size.

To Cyree, thank you for sitting on the end of the couch so auntie would have room enough to sit with you and LéVertis.

To Rondrell, thank you for tying my shoes and for all the failed work-out routines you

put together and those nutritious meals you prepared for me in an attempt to help me lose weight.

To Dr. Patrick Sawyer, may God bless the hands that were instrumental in giving me back my life.

To Dr. John A. Millard, thanks for all of the much needed nipping and tucking (smile). You are a wonderful doctor.

To Gwen, thank you for your friendship & support and your work of art!

To Chalice, thank you for being the best beautician on earth.

To all the brave people who were willing to share their own painful stories in an effort to save my life and the lives of so many others: Carnie Wilson, Randy Jackson, Al Rocker and Big Boy.

## Contents

Foreword . . . . . . . . . . . . . . . . . . . . . . . . . .i

1. A Bright, Beautiful, Precocious Child . . . . 1
2. Not My Goodies! . . . . . . . . . . . . . . . . . . 11
3. Decisions Determine Destiny! . . . . . . . . 23
4. Meeting Mr. Right . . . . . . . . . . . . . . . . 35
5. Wedding Bells and a White Gown . . . . . 47
6. I'm Coming Out . . . . . . . . . . . . . . . . . . 59
7. One Life to Live. . . . . . . . . . . . . . . . . . . 71
8. Breaking Up is Hard to Do . . . . . . . . . . 83
9. Nip It, Tuck It, Do Something With It. . . 93
10. Waiting to Exhale . . . . . . . . . . . . . . . 105

# *Foreword*

By definition, when I first met Terri, she was a morbidly obese woman with five co-morbidities (associated medical problems). This statement is not meant to be callous or too medical and analytical. It is just that in my primary evaluation of a patient I need to define in a relatively brief period of time whether obesity surgery is a safe and reasonable option for them. I need to find out who they are, what their medical issues are, and if they are ready to be considered for this profound life change. I look at the medical and historical information they bring with them and I do a comprehensive evaluation—what we call a "History and Physical." This has been the cornerstone of medicine since the beginning of history. But, that is probably the last time I saw Terri as simply "a patient."

To better understand her journey and how I have grown to view her as a true emblem of how to succeed with any major life transformation, I need to first let you in to my very particular view of bariatric surgery. First, I need to discuss the patients. I am constantly reminded throughout the course of my day, every day, that my patients are "different." This is not always said in a critical manner. Those with whom I

work and those who merely observe my busy practice and the way we treat our patients often ask "What is it about these bariatric patients that is so special to you? You had a very busy practice before doing bariatric surgery and they are 'high risk'. Why do it?" That question gets at the essence of what makes my patients so special—they are different than most patients. In fact, they are different than most people any of us know. This difference is what makes them so remarkable. The truth is, they have had the honesty and insight to look deep within their health and self and say "I do not like what my life and health are like now." They see that their weight is negatively affecting their world in critically important ways.

Then, they have taken the next step (what I see as the heroic step). They say "I am going to make a change." This is a critical and difficult step to take. As hard as it is to recognize the need for a change, it is one-thousand times harder to take action. Having the strength and fortitude to look within one's self, then take action—that is a rare act of honesty and bravery. So, when I meet a patient for the first time, I know that they have already taken this most dramatic series of steps. In a person's life this level of decision making is entertained quite rarely. Other than getting married or having children, there are few things one can commonly do in his or her life that involve a major life commitment that will

have endless, lifelong implications. That is how I view my patients—they are heroic in vision and profound in commitment.

But then there is the "doctor" factor. There are certainly a number of reasons why one would consider a field in bariatric surgery. And, to some degree, all of these elements probably apply to most of the accomplished physicians in the field. Having done well over 1000 primary bariatric surgical procedures and having developed a program into a nationally recognized, Bariatric Surgical Center of Excellence, I feel comfortable hazarding a vision of what makes a bariatric surgeon. But, I would be doing you an injustice to say that it is as simple as loving the technical skills required in the surgery or enjoying the high-profile nature of the art or reveling in the patients' weight loss. I know that, for me, it is all much more. What matters most to me is the honor and pleasure I get from my patients allowing me to help profoundly change their life. It is a rare privilege to be entrusted to help someone change his/her life, health, and perspective. Such is the power of bariatric surgery. Who wouldn't want to share in this wondrous transformation? The funny thing is that my patients always say how much I helped them. I see this as far from the truth. The amazing thing is that they don't realize that they do it almost entirely on their own. What starts as a well-orchestrated program and grows into a complex surgical procedure

ends up being something quite simple—a person with a vision of what they want in life and the newly acquired tool they can use to achieve it. What they **do** with this tool is what makes the person and their results. Like any other tool, it is no more effective than the person using it. Fortunately, this is the gift of my patients—they understand the importance of the opportunity and they run with it.

And, this is where the wonder of Terri comes into play. When I first met her on January 14, 2004, her profile was the following:

Age: 29
Height: 5 feet 8 inches
Weight: 291
BMI (Body Mass Index): 44

Co-morbidities: Gastroesophageal Reflux Disease (Heartburn), Joint Pain, Menstrual Irregularities, Hypercholesterolemia, Hypertriglyceridemia.

The date of her laparoscopic, Roux-en-Y, gastric bypass procedure was February 17, 2004. At the date of her surgery she was 299 lbs. (in her words, "NOT 300!") and had a BMI of 45. She was the first Roux-en-Y gastric bypass of five that week.

The details of her post-operative course are that at one week she was down 13 lbs. At three months, down about 31 lbs. At six months, down 75 lbs. And at one year, down 111 lbs.

and at a BMI of 22. (Her goal BMI of 25 would put her at 164 lbs. and she passed that number resoundingly. As you will learn, she is an overachiever!)

As impressive as her weight loss has been, the miracle of Terri is not how much weight she has lost. More impressive to me and all who know her is what she has done with the opportunities she has gained in the process; what she has done with the tool. I remember quite distinctly a discussion she and I had at one year post-op. I asked her what the best thing about her weight loss was. I asked the usual questions one would ask someone who went from morbidly obese to many people's absolute "ideal weight and size." Is it the weight loss? The new clothes? The attention from others? The self-esteem? The resolution of your medical problems? The dropping of risk factors for major medical problems? Not being the largest person in the room? To each query she said, "Those are all good, but definitely not the **best** thing." Confused that I was unable to hit on what is best about her weight loss I finally asked, "Terri was anything 'best' in your weight loss journey or was it all just 'good?'"

Her reply was quite telling. She said "The best thing about losing all that weight is that I no longer have to think about it! I cannot tell you how much I thought about it before." Then she proceeded to run through a 5 minute lecture on

specifically **when** she thought about her weight while she was morbidly obese. A few things I can remember off-hand are: "When I woke up, when I got out of bed, when I took a shower, when I brushed my teeth, when I talked to my husband, when I got in the car...." She went on and on. And she was not kidding. She had spent a lot of time thinking about all of the time she had wasted in her life concerned about her weight. Clearly, as she describes it, her weight was a total preoccupation. As she said, "With the time and energy I spent thinking about my weight I could have learned a new language every week!"

The wonder of the surgery, she reflected, was not just the physical transformation and the health benefits, but rather the fact that she could "free her mind up to think about something...anything...else." And, as you will learn from her, what you do with that freedom can be quite remarkable. Terri has never been a shy or demure person. As she says, "Even when I was big, I was 'out there.'" She made a professionally produced CD of gratitude for me to listen to while I was taking care of her, she had a business doing singing telegrams, and she was performing the National Anthem for Denver Nuggets NBA basketball games. She developed a real estate company with her husband and has been quite successful. Her interests and passions are great and broad and they started

well before her weight loss surgery.

But, the process Terri will share with you is one of transformation and vision—one in which she took control of the one thing that she felt was undermining her at every turn. Those who know her did not see this negative process. We all just saw a lovely lady with a weight issue and some bothersome medical issues. But, Terri knew what was best for her and she has not squandered the opportunity or ever taken for granted the new life she has made for herself. She remembers where she came from and wants to help everyone live their potential. As I always say to anyone who will listen, "I get to see miracles every day." And I am honored and blessed to have had the privilege to be a part of the miracle that Terri has become.

*—Michael A. Snyder, MD, FACS, PC*
*The Denver Center for Bariatric Surgery, PC*

## Chapter One

## *A Bright, Beautiful, Precocious Child*

By looking at me today you would never guess that I once weighed over 300 pounds! But it's true, I was 300 pounds, most of which was unwelcome and unwanted fat!

Unlike some people I know, my weight gain didn't start after pregnancy or some cataclysmic event. I started getting fat as a child, when I was about six years old.

For those who would like to psychoanalyze me to discover some deep, dark secret behind my weight gain, let me say to begin with, it wasn't due to being deserted or abused by my father or mother. They were not absentee parents. The fact is I was raised in an ideal home. My mom and dad were great parents who lavished love on my brother, sister and me.

My childhood is filled with the fondest memories of a happy, well-adjusted family living in a middle-class neighborhood. My parents worked hard to provide a comfortable place for us kids. They were involved in our lives before and after school and in our daily activities.

I remember how proud my dad was of my brother, Steve, when he became the varsity quarterback for George Washington High School in Denver, Colorado. And mom, believe me, mom could yell with the best and loudest in the stands.

Steve

I'll never forget one game in particular. Steve got injured and was lying on the ground. As the medical staff and trainers rushed out on the field, so did my mom. Only she had to scale an eight-foot fence that separated the playing field from the stands where she was sitting.

That night she was wearing a long coat that came down to her ankles. Most women could have never made it across the fence dressed like she was, but it didn't even slow her down; she was up and over that fence like Wonder Woman.

I've thought about that episode many times and I still can't imagine how she did it, but she

did.  Her son was hurt and nothing or nobody was going to stop her from getting to him.

Each of us children knew what it was to experience unconditional love.  Our acceptance was not based on our accomplishments but who we were.

Naturally, there was a measure of pride when Steve was the star quarterback, for my sister, Teresa, (AKA) "Miss Personality" and for me when I made the varsity cheerleader team, but their love went far deeper than that and we knew it.

No, I can't blame my weight gain on being raised in a dysfunctional home.  If it was, you can be certain we emphasized the "fun" in dysFUNction!  Life at the Jackson's house was everything a child could hope for.  It was like a dream come true!

So, what caused me to start my ill-fated journey to Fat City at that tender young age if we had such a wonderful home and loving parents?

To put it simply and succinctly, I was overweight because I overate! The fat I was accumulating around my middle and on my hips was the result of "**overactive silverware!**"

My parents owned Jackson's Sandwich and Creamery at the corner of 26th and High Street in Denver.  They made the most delicious burgers

3

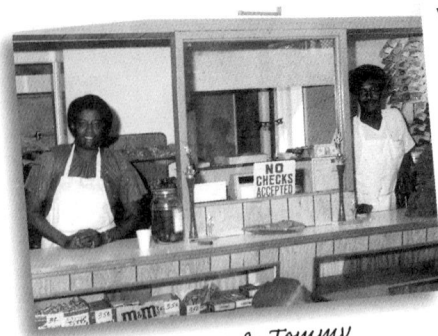

Imogene & Tommy
Jackson's Sandwich and Creamery

you ever lapped a lip over or sunk a tooth into!

The fresh-cut fries were always cooked to a golden brown and the thick, creamy milk shakes were the best in town. I made certain that I had a daily dose of those "comfort goodies."

My own rendition of an old church song went like this:

"Hallelujah what a thought,
A juicy hamburger and a great, big malt!"

But it didn't stop with burgers, fries and milk shakes. I loved Snickers candy bars!

As children we were taught to love people and like food but with me it was different, I loved both people and food, especially junk food and more especially Snickers!

Terri's 5th Birthday

Before you become too harsh in your judgment of my childhood behavior,

how many kids do you know who would choose broccoli over fries and cauliflower over Snickers? I was a normal child! Like any other well-respected kid, I chose what tickled my taste buds (burgers, fries, milk shakes and candy bars) rather than the proverbial good-for-your-eyes carrots! After all, I could wear glasses for my eyesight.

Early on I learned that I could manipulate others into giving me what I wanted which, at that particular time, just happened to be Snickers candy bars.

I had a pretty good system going for a kid my age. Let me tell you about it!

Even though my brother and sister were a few years older than me they took me everywhere with them. I'm not sure if that was my parent's or their idea but as it turned out it worked magically in my favor.

As you can imagine, Steve, being the star quarterback on the varsity football team, had a lot of girls wanting to meet and date him. My sister, Teresa, pretty as a peach in her ROTC uniform, with her flashing eyes and beautiful smile, had the boys falling all over themselves to meet her.

Teresa

I became the official gatekeeper of Teresa and Steve's

social calendar!  Admission—one Snickers candy bar. Of course, the giant-sized bars got preferential treatment. It wasn't long until I had an almost endless supply of those wonderfully delicious, fat-making critters to munch on.

In school I received my share of teasing from the other kids. I remember how the boys used to taunt me with:

"Fatty, fatty, two by four;
Can't get through the kitchen door!"

I was more than just fat; I was also tall for my age. I could really push my weight around so when the taunting was going on it was usually from a safe distance. Once a kid tried to kick me, but as he did I grabbed his leg. Then I drug him around the baseball field on his back.

Despite the harassment, if you can call it that— I choose to think of it as child's play—I was very happy. Loving parents, adoring siblings, candy bars galore, hamburgers, fries and milk shakes! What else could a person ask for?

When I look back on my childhood I am convinced I had a common physical malady that fails to be listed in the doctor's handbook of dangerous diseases: "Right and left elbow-itis!" The symptoms are: every time the elbow bends the mouth opens.

I am not overlooking the terrible fact that some people have physical disorders that cause

them to be overweight and I sympathize with them. Studies have shown that genetics are a vital part of an individual's physical makeup.

In a Danish study of 4600 children adopted within the first year of age, those who suffered with morbid obesity were born to a parent or parents who also suffered with weight problems. Whenever a person is suffering with obesity it is wise to look at their ancestry to see if the problem had its origin there. Of course not all obesity is hereditary, some is the result of overeating.

*It wasn't just my "genes" that made me bust the seams of my "jeans!"*

Though we didn't realize it at the time, no doubt my problem was part genetics and part the amount I was eating! Throughout my childhood I continued to grow taller and rounder. The more I ate the bigger I became and the bigger I became the more I ate.

From the time I was six until I was nine years old I continued to gain weight at a steady pace. Why? Because I continued to eat the same gloriously delicious hamburgers, fries, milk shakes, ice cream sundaes, and those ever present Snickers! By continuing to do the same thing I had always done I continued to get

the same thing I had always gotten—FAT and FATTER!

Oddly enough the warning bell never sounded in mom or dad's mind. I think it was because I was a bright, healthy, active child who interacted well with my brother and sister at home, other children in the neighborhood and made good grades at school. No one saw that a monstrous problem was developing and that it would hound me relentlessly until I eventually tipped the scale at over 300 pounds.

I once read the definition of insanity, and it fit me perfectly!

> "If you continue to do the same thing you've always done, the way you've always done it and expect different results, you're insane!"

## What and How Much!

Let's face it I was fat because of "**What** and **How Much**" I ate! I am living proof that you can not possibly eat so much that it makes you skinny to carry it. If that were possible I'd have been a bean pole rather than a Fat Alberta impersonator.

Little did any of us realize that at a very tender age I was digging my own grave with a knife and fork! I was on a fast track to diabetes

and a massive heart attack and didn't know it. Later in life I learned the truth of what I was doing to my heart and other vital organs.

Thank God, I was able to alter my course and get the help I needed before it was too late.

Between the ages of six and nine I continued my merry way, smothering the fries with ketchup, a tad more mayo on the burgers and an extra scoop of ice cream in those thick chocolate malts! Not to mention those lovely Snickers. And, guess what? I continued the upward spiral!

I knew I was bigger than the average girl my age both in height and around the middle, but it didn't really bother me. I wasn't interested in boys at that time so their taunting me about being fat was like pouring water on a duck's back; whatever they said ran right off. Besides, if push came to shove, my size gave me a distinct advantage and if that didn't work I could always call on my big brother for help.

If I were to describe my life in those early years I'd have to say it was fantastic, despite my being fat. I was a happy child. I loved my family, enjoyed school and I had a ton of friends (no pun intended).

As I look back now I can see many things that could have been done to curb my weight gain, but looking back can't solve the problem. I was a well adjusted kid who happened to appreciate

9

the very things that made me fat.

Tommy & Imogene

Who do I blame: my parents for allowing me to eat those scrumptious hamburgers, crispy fries and luscious chocolate milk shakes? Perhaps my brother and sister for letting me tag along with them, which led me to devise the candy bar scheme? Or maybe I should blame myself for being a food-loving kid!

No!

I don't blame anyone!

Mom and dad were the best parents in the world, who did the best they could! I couldn't ask for a better brother and sister than Steve and Teresa and I certainly don't resent getting to go with them; they were always super to me.

**Simply put, I was a bright, beautiful, precocious child who was overweight because I overate!**

## Chapter Two

### *Not My Goodies!*

I kept growing, growing and growing in all directions both in height and around the middle throughout those formative years. By the time I reached my ninth birthday the warning bell had sounded in my mom's ears and she started me on my first series of ill-fated diets.

Imagine, if you can, my daily diet of those things I described in the previous chapter suddenly taken away and replaced by things like celery, grapefruit, broccoli, carrots and other yucky things from those food groups. I went into immediate withdrawal. My stomach thought my throat had been cut and hunger stalked me like a ravenous lion!

Earlier I told you about my ingenious plan of action to get Snickers from Steve and Teresa's

would-be suitors. Well, when mom started me on those horrible diets ingenuity arose once more. This time it was in the form of hiding and hoarding the good things and, even at that age, I was clever enough not to put my whole stash in one place. I wanted to be sure that if anyone found my stuff I had more someplace else.

I was a bright child to begin with and when they started messing with my goodies I became even more creative. It wasn't that I liked being fat, I didn't like that at all, but I was a junk-food addict and I had to protect my inner cravings. I couldn't recall a single day in my life that I had not had at least one candy bar.

I have now learned the value of dieting but to a nine-year-old child it was sheer punishment, equal to prison, being stretched on the rack, or made to walk the plank. How could my loving, caring mom do such a terrible thing to her precious little (but not so little) angel?

Evidently my weight gain was not due to inactivity. I was on the go constantly, either at school, with my brother and sister, in church or helping in the sandwich shop! OOPS! That may have been where I was too busy doing my own thing while everyone else was busy with customers.

Back to those wonderful diets! I was on so many different weight-loss programs I totally lost count. I remember some because they

were so terrible that they are forever etched in my memory.

You've already read of my relationship with chocolate milk shakes, well, my dear mom, bless her heart, read about a diet that came in a can that was supposed to make me slim down fast. The directions said you could chill it, shake it up and it would be as rich, smooth and satisfying as a thick creamery malt. WRONG! Don't let anyone convince you that the canned stuff is in the same league with the real thing. It didn't come close to matching what I had been slurping down in our wonderful sandwich shop!

Without a doubt I would have lost a lot of weight if mom could have kept me on that straight-from-the-can liquid. But she didn't know where I had my stash hidden and when she wasn't looking I was adding some zest to the otherwise bland fare she was feeding me.

*Princess of the yo-yo diet world!*

My weight was up and down so much I became the little princess of the yo-yo diet world.

Can you imagine how difficult it is to convince a happy-go-lucky child that the best thing for them to eat is grapefruit? Oh yes, we tried that one too. We read that there was something in grapefruit that would burn the fat right off my

hips, thighs and around my middle, as well as other locations on my body.

It wasn't that I especially disliked grapefruit but it was a far cry from what I had grown accustomed to. There was nothing about a grapefruit that could ever replace my craving for chocolate. I think I was a "chocoholic" from birth. Although I really liked only three kinds of that luscious stuff—light, dark and white.

Every diet we tried worked to some degree. I would lose weight, but as soon as I stopped that particular diet everything I had lost, and more, would find its way back home. Fat was like a bad penny, it kept showing up on me.

A family I know had a granddaughter who was like the little boy, Pigpen, in the Charlie Brown comic strip. Her grandmother would get her all clean and dressed, ready to go out but between the house and the car the child could get all messy and her clothes would look terrible. Her grandmother said, "How can you get so dirty, so quick?" Tarrah would answer, "The dirt just jumps up on me!" That's what fat did to me: it just jumped up on me!

*I could smell bacon frying and gain five pounds!*

I've known people who could eat anything they wanted and not put on an ounce. I could

smell bacon frying and gain five pounds!

Another diet we tried was boiled eggs, hamburger patties and Melba toast. I have to admit, that diet was not too bad to begin with, after all I loved hamburger patties, but the way I liked them most was on a bun with lots of mayo, a couple of slices of cheese, tomato, lettuce, pickles and ketchup, not a dry patty, a hard boiled egg and those tiny, thin pieces of hard, over-cooked bread. Within a few days I had consumed so many eggs I thought I was going to cackle like a hen in a barnyard.

The yo-yo continued! My weight would go down for a little while, then right back up again but each time it came back it was to a new plateau! I estimate that I lost over two hundred pounds as a child, but I gained it all back and more besides. Not to mention what it was doing to my health.

By the time I reached my tenth birthday I was starting to become aware of what my life was and what I wanted it to be. That was the year I became a born again Christian.

While my parents valued my decision to dedicate my life to Christ, they were more than alarmed with my weight. It was totally out of control, despite the diets.

We tried everything from cutting down the portions I ate to more exercise. I even stayed with my mom's friend, Baba, (who later became

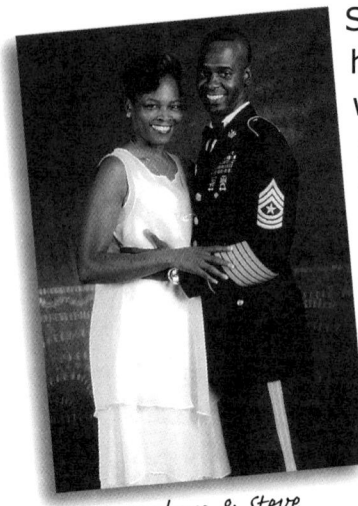
Barbara & Steve

Steve's wife) in an effort to help lose weight. (I stayed with Baba because my mom was also struggling with her weight and mom thought Baba would be able to help me.)

It's amazing how little things make lasting impressions on your mind. While I was staying with Baba she washed some of my clothes and when she took them out of the dryer her little girl, Nikki, noticed that a pair of my shorts had little balls of material between the legs.

When she inquired of her mother what those little balls were, Baba tried her best to explain in a way that would not be offensive to me. I knew, however, that it was because my legs were so fat they rubbed together and the rubbing caused the material to ball up. Even at the age of ten the fat embarrassed me.

Embarrassed, yes, but that was not enough to make a ten or even an eleven-year-old stick with a diet long enough to lose all the weight I needed to lose.

The yo-yo dieting became a pattern with me. As soon as mom heard about a new one we

had to try it. The trouble with most diets is, they promise the moon but can't deliver. More often than not it's because people don't change their eating habits and excessive food makes excessive fat.

*Terri at 12*

As soon as I completed the prescribed number of days for a particular diet I was ready to dive into a juicy hamburger and a plate of fries smothered in ketchup. I'd wash it down with a creamy double-thick chocolate milk shake and finish it off with an indescribably delicious Snickers candy bar.

As you already know any weight I lost wasn't lost at all but was just temporarily misplaced. I quickly found it again.

We didn't realize that my pattern of losing weight and gaining back more was setting me up for major problems later in life.

As birthdays clicked off I continued to fight the battle of the bulge. If my weight had been drawn on a visual chart it would have looked like the Dow Jones, with its peaks and valleys but always going up.

I thought that when I entered puberty I would become interested in boys and naturally slim down. But my pre adolescent years were setting the stage for a long up-hill battle that I

was destined to lose over and over again.

I don't mean to leave the impression that as I grew older (if going from six to twelve can be thought of as older) that sadness or despondency was a way of life for me because it wasn't. With the exception of my weight gain (which I had started to notice) and those awful diets that prevented me from enjoying my favorite foods, I was happy as a lark.

As I said earlier, life at the Jackson home was fun. We interacted with each other as a family. We played hard, worked hard and prayed together for God's will to be accomplished in each of our lives. Our house was filled with love and laughter, so I don't want to paint a sad picture because that wouldn't be the truth.

### *Teresa was my model!*

After Steve got married and moved away, Teresa and I were left at home with our parents. Teresa was my model! I wanted to be like her more than anything in the world. Throughout the years I watched the way she conducted herself. Always a perfect lady, always polite to our parents, her teachers and the older people in church and always popular!

She wasn't known as "Miss Personality" for nothing. To me, Teresa was the prettiest, most

lovable girl in school, the state or even the world. I loved her then and that love has never stopped. She is still as precious to me as she was when I was a child.

I'm sure we had disagreements when we were children. Such a thing would be completely normal, but I can only recall two incidents in all those years. Once I tore up all her school pictures and scribbled in her yearbook because I didn't like her boyfriend. She was furious, but I considered it my job as her little sister to look after her.

*Teresa & Terri*

The second time was when a boy came to the door and asked for her. She told me to tell him she wasn't home. So I answered the door and said, "Teresa told me to tell you, she's not home."

It could be that I have such a genuine love and respect for her that any negative thoughts I may have had are forever removed from my memory. Everyone should be so blessed as to have a sister like Teresa!

Between the ages of nine and twelve things were happening inside me. I was experiencing

all the emotions of going from childhood to adolescence. As my body chemistry changed so did the image of myself. I saw other girls slim, trim and pretty and I wanted to be that way. Sadly, the harder I tried to lose the, now unwanted, fat the harder it clung to me.

Undaunted by the fact that I was taller and fatter than the other kids in my class I continued to make a name for myself. I worked hard to get good grades and, following the example that Teresa had set before me, I was kind and courteous to my teachers and elders.

But woe be to those smart-aleck boys that made fun of me. I was big enough to throw my weight around and tough enough to make them sorry for crossing my path. In spite of being fat I was as quick as a cat and as fast as a hiccup. I was pretty good at some sports and lousy at others. I could jump rope, shoot baskets, hit a softball, throw a pretty good pass and kick a soccer ball farther than any of the boys in my grade, but I couldn't play volleyball. I remember diving to keep the ball from touching the ground and ending up with both arms through the net. That's when I decided to try out for cheerleading.

One thing I tried time and time again but could never master—climbing the rope in gym. It wasn't that my arms were weak; my problem was Mother Nature!

When my arms would try to pull me up the rope Mother Nature would employ her little gravity trick on the "fatofmythighs" and pull me back down to the gym floor.

Let me help you with the above-mentioned malady by hyphenating the word, "fat-of-my-thighs." Actually, it was more than fat on my thighs; those ornery little critters known as fat cells, bunched up on various parts of my anatomy and claimed squatter's rights.

It wasn't until I decided to have gastric bypass surgery that those unwelcome, unloved, unwanted and unappreciated pests were served eviction notices and forced to get out.

One little fat cell floating around in your system is cause for concern because those rascals multiply faster than rabbits. The next thing you know, that cell you left unattended has invited all of its friends and relatives to have a get-together somewhere conspicuous on your body.

*If you give a fat cell an ounce
the next thing you know
you'll have several pounds of unsightly blubber!*

The only coming-out party I had as a twelve-year-old was over my belt and the sides of my chair. By that time I knew something was

21

drastically wrong, but I felt helpless to change it.

To say my mom was frantic at that point would be stretching the truth, but she was deeply concerned that I was destined to follow her footsteps and that of my grandmother. Both had suffered with obesity throughout their lives.

*Terri at 12*

Her concern forced her to put me on yet even more diets; none of which had a lasting effect except that once they ran their course I went back to eating the things that put the pounds on in the first place.

**The "Yo-yo Princess"**
**was very much alive**
**at the age of twelve**
**but changes were on the horizon!**

## Chapter Three

*Decisions Determine Destiny!*

Eye shadow, lipstick, fingernail polish, perfume, hairdos, and boys, especially the last item on the list, boys! No more of those kiddy games—hop-scotch, jacks, dolls and buggies—for this girl, I was growing up.

Things I had never experienced were coming alive in me! Boys all of a sudden looked different. I began to observe that not all of them were misfits of the human race or some kind of freak from another planet. I really did want them to notice me.

Except for my dad, my brother Steve and a few elementary school (tee-hee, giggle) boyfriends, I thought all males were made of hammers, nails and puppy-dog tails. Boys

were to be begrudgingly tolerated, certainly not liked!

But, Mother Nature! Yes! The same one who turned on the gravity switch and drug me down when I was attempting to climb that wretched rope in the gym, did it to me again! This time she flipped her hormone switch and the next thing I knew, boys started getting cute.

At first they were just cute, then they started getting handsome, dashing, daring and desirable but that was a few years later in life. I must admit I wasn't prepared for the changes that were taking place in my body and mind.

All of my life dolls had been my best friends and boys, my worst enemies. At thirteen, dolls may still have been my best friends, but I was having a lot more fun with my worst enemies.

*Tragedy of tragedies!*
*I became allergic to chocolate!*

In addition to discovering that boys were not as bad as I had always thought, I made a second even more startling discovery! That little hormone switch Mother Nature flipped also made me allergic to, of all things, **Chocolate**! Not only did it make me fat but it caused my

beautiful smooth skin to break out in zits, blemishes or that terrible "p" word—pimples!

At thirteen it would have been bad enough to just be fat or have pimples but, wouldn't you know it, I had both!

I don't remember anything that took place during my terrible two's, but I remember well the terrible trauma of thirteen.

It would have been easier to stay a little girl than to grow up and play the hand I had been dealt. I wanted

*Terri at 13*

to be slim, trim, petite and pretty like the other girls in my age group. Sadly, only one of those attributes fit me. I wasn't slim, trim or petite, but I was pretty and I had to make the most of it by also being outgoing, jovial and charming.

*Are you pregnant?*

I'll never forget the day my mom had a heart-to-heart talk with me. Keep in mind; I was only thirteen years old. Mom said something like, "Terri, I want to ask you a question and honey, you can tell me the truth. Are you pregnant?" I

can't begin to explain my absolute surprise at her question.

Even though we went to church and she knew that I had committed my life to Christ, my mom was not naïve enough to think that I could not be seduced by an older boy. Her question was very valid and I now understand why she asked it. I assured her that I was not pregnant!

As I look back on that incident it's almost comical, being intimate was the farthest thing from my mind. In fact, I had just begun to like boys. I don't think I had ever let a boy do more than hold my hand.

I hate to think what my dad would have done to me if I had been pregnant. Probably after killing me (figuratively speaking) he would have turned me over his knee and forcefully applied his big leather belt to my gluteus maximus until I couldn't sit down.

You may be wondering why my mom would ask her daughter such a question as that. Here's why! Previously I told you about one of my maladies—"fatofmythighs." Well, mom asked her question because of another malady called "fataroundthemiddle!" Simply put, I was "fat-around-the-middle!" She couldn't tell if it was fat or if I was carrying a baby. Thank God she cared enough to ask!

At no point did we abandon dieting. Somewhere between thirteen and fifteen-years-old

we tried WW, high-carb, low-carb, no-carb, light-carb, dark-carb and everything else promising weight loss—all with little or no success.

I tried skim milk with special lo-cal cereals, breakfast bars and meal-replacement high-protein drinks. During that same time period I ballooned to 180 pounds.

*Inside my fat body there was a shapely girl trying to get out!*

Most young ladies my age, who had tried as many diets as I had and failed, would have given up hope of ever being thin. But not me, I knew that inside my fat body there was a thin, shapely girl trying to get out!

It would have been easy to withdraw into a shell of despondency or throw a big pity party for myself but that wasn't me. I was fat and I knew it, but I had some wonderful attributes going for me. So, despite the fact that I was a roly-poly, I decided to make the most of life.

My first great adventure was to try out for the varsity cheerleader team. At some point in my life someone had planted the idea in my mind that it's better to set your goal high and just get half of it than to set it at nothing and get the whole thing. My first lofty goal was to make the team.

I don't have to tell you that it was an uphill battle. First with myself, then to convince others that I had what it took to be a part of that illustrious group.

Can you imagine all those pretty girls, almost every one of them magazine-model thin, in those tiny little dresses jumping and yelling on the sidelines and me, as big as a running back, on the same team?

*Terri*

I'm sure many of the kids in school were saying, "No way, Jose!" They saw me fat, overweight and out of shape, but what they didn't know was, I had the will to win.

*Survivors only survive. Winners Win!*

Tagging along with my sister, Teresa, had taught me a marvelous lesson: you attract more bees with sugar than you do with vinegar. If there was one thing I had, it was plenty of sugar. Those Snickers didn't go completely to waste, I utilized some of that sugar and sweet-talked my way into the governing body's heart. I not only made the team as a freshman, I made the varsity cheerleading squad! I can't

28

tell you what making the squad did for my self-esteem. That single accomplishment told me that I could succeed if I made up my mind to do something. I found out that survivors only survive but winners win and I was a winner! (My message to all those girls who are aspiring to be a cheerleader—go for it!)

Part of the will to win was to prove to myself that I could overcome the snide remarks that some of the uncaring students made about my size. I also realized that part of my desire to succeed was to mask the pain and appear normal. No one knew how many nights my pillow was wet with the bitter tears of remorse, shed because I was obese.

*The mask I wore and the songs I sang said everything was okay!*

The mask I wore in public said everything was okay, but inside I was hurting so bad I wanted to die.

I venture to say that the vast majority of people don't have a clue as to how painful their careless remarks are to those who constantly battle their weight.

Every time I see an overweight person I want to reach out in tender love and tell them to hold on to their dreams and never give up.

A thousand times over I looked in the mirror and hated what I saw. I wanted to be like other people. I wanted to be rid of the bulges and rolls of fat. I wanted a slim waistline and shapely figure. What I really wanted was to be skinny as a rail, pencil thin, but what I wanted and what I was were two totally different things.

It was just not fair. I was living in a land of great possibilities encumbered with gobs of unwanted fat. But then, who said life had to be fair? If I really wanted to go places and do things I was learning I had to blaze a trail for myself.

Waiting for someone to take me by the hand and lead me through the maze wasn't going to happen and self-pity was as worthless as a sidesaddle on a razorback hog. I didn't become a cheerleader by waiting for someone to run interference for me. That was an achievement I accomplished by sheer determination and it set the stage for every goal I have realized since.

When I was a little girl my parents wanted me to lose weight because they saw what it was doing to my health, but when I reached my teens it became something I wanted to do. By then however, the die was cast and diets were of little or no value.

How many times had I heard my mom say, "Young lady, you clean your plate or you can't have any dessert?" If we had known what those

last bites of food, and then the desserts, were doing we would have done things differently.

Cleaning the plate was a throw back to times when families were struggling to make ends meet and it was unconscionable to waste food. Neither my parents nor their parents realized that it would have been far better to feed the left-overs to the pigs or throw it away than to make the kids eat it. We were all products of the teaching of the time.

Between the ages of thirteen and sixteen I was in a state of constant change physically, spiritually, mentally and emotionally. Those years were both wonderful and terrible. As I developed into a responsible young lady I was fighting the demons of fat and all the unhappiness it caused.

*As I gained mentally I also gained pounds!*

To compensate for being less attractive than the slender, statuesque girls in my class I studied hard to become academically superior to them. I can't say that my plan worked or that I became smarter than they were, but the studying helped my mind to grow by leaps and bounds and it helped me to keep things in perspective. It's too bad that the brain development didn't cause the body fat to melt away! As I gained mentally I also gained more unwanted pounds.

Battling obesity taught me some invaluable lessons that have stayed with me throughout my life. Sheerly by size it would have been easy to bully and bluff my way through school, but that was not my method of operation. I learned that self-control could do far more for an individual than bluster and coercion. I am by nature a people-person and the very thought of intimidation has always been repulsive to me.

Once again the things I learned from "Miss Personality" came to the forefront. Kindness and a smile were to become my trademarks. During those difficult times I smiled even though my heart was breaking.

*Terri at 16*

As a child I was taught that an idle mind was the devil's workshop so I chose as my motto: "Get busy and stay busy!"

School, church, cheerleading, a date now and then and endlessly pouring over the books to make the highest grades possible kept my mind active and alert. Somewhere in the deep recesses of my tenacious brain I knew that someone, somehow, someday would come up with a viable solution to my weight problem, and when they did they would find me standing at the front of the line.

*Decisions determine destiny!*

Just as an individual's choices create consequences, the decisions they make determine their destiny!

By the time I was sixteen my parents and I had been fighting my weight war for ten years. That's longer than it took to defeat the Axis in World War II. The worst part was my enemy was not even close to surrendering. During that time I had won some battles but I was still losing the war.

We could have all gotten discouraged and quit. Except, the Jacksons were winners not quitters. Tommy and Imogene were entrepreneurs who owned their own business because they were winners. Steve Jackson was the quarterback of the varsity team because he was a winner! Teresa was "Miss Personality" because she was a winner and Terri Jackson was a cheerleader because she was a winner. No one in my immediate family carried the stigma of being a quitter and I wasn't going to be the first.

I refused to give in to **PMS**, which, in my case, was "**P**oor **M**e **S**yndrome." Instead I was determined to be the most popular fat girl in school. Not the most popular girl, but the most popular fat girl! Did I achieve that goal? Who knows and ten years later who cares? The

important thing is that decision helped to shape my destiny!

## Chapter Four

### *Meeting Mr. Right*

When I was thirteen I tried to act as if I was twenty, but four years later I had pretty much settled into the normalcy of a seventeen-year-old trying to get through high school and plan for the future.

I have to admit that, with the exception of my weight and its attendant miseries, I had a happy childhood and adolescence. School was not the drudgery for me that many of my classmates declared it to be. My parents, as well as my brother and sister, had taught me to place a high value on education. I knew it was one of the keys to my future. I had applied myself to learning and not simply marking the time until graduation.

If I were to succeed in life I knew it would not be the result of a single event but a succession of events and schooling had a prominent part to play.  My parents didn't demand all "A's" but they did expect me to do my best.

We had an agreement the first year I tried out for cheerleading—grades first and cheerleading second.  If I didn't maintain my grade level the extracurricular activities would have to be given up!

To maintain my grades meant that I had to forego some of the other activities I would have enjoyed.  In the big picture, however, it was a small price to pay to stay on the squad.  I graduated with a  grade point average good enough to get a scholarship to college, even though I had already decided that any further education would have to come later.  I had more important fish to fry than sitting through four more years of lectures!

Considering the large number of kids who became drop-outs between their freshman and senior years, I thought it was quite an accomplishment just to walk across the stage in my cap and gown to get my diploma.  I have since learned the value of advanced education and made it a practice to continue to study and learn.

At seventeen I was like most other teenagers and already knew everything there was to know

about everything. I was really amazed at how smart my parents became between my seventeenth and eighteenth birthdays.

If you had asked me about my goals or what I wanted to be after I finished high school I probably could not have given you an intelligent answer. I was not looking to take the world by storm but to earn enough money to enjoy freedom from the classroom.

*Terri at 17*

I was already working part-time as a receptionist for an apartment community, and I liked the idea of having my money to spend on whatever my heart desired: an occasional Snickers bar now and then and some of the other goodies my body hungered for. Yes, I still enjoyed them even if they were one of the main culprits that kept me from having the slim, trim model-figure I desired!

Only those individuals who have fought the "fat war" know what it's like to crave the very things that are so bad for you. There were times I thought I couldn't make it one more hour without a chocolate morsel in my mouth. The problem was I was never satisfied with one little M&M; it took a whole bag and, generally

speaking, the bigger the bag the better.

When I talk about having my own spending money I'm not casting a reflection on my parents or inferring that they didn't give me money when I needed it. While we were not rich by any stretch of the imagination, we were not poor. My parents worked hard and managed their money very well so that my brother, sister and I were more than adequately cared for. I wanted my own money because I had entered the age of independence. I thought I could make it without anyone's help.

It didn't take me too long to realize that the money I made working for Rotella Park Apartments wouldn't go very far if I had to pay rent, lights, water and gas, make car payments, buy insurance and fuel and, from what was left over, buy groceries and clothes.

When I think about it that may have been the solution to my weight dilemma! If all those expenses mentioned above had been deducted from my meager check there would have been precious little, if anything, left to buy food, let alone the fat generating sweets.

*Mom and dad were always there for us!*

My parents were very supportive of my brother, sister and me. They wanted us to make

something of our lives, to be constructive, not destructive. They taught us spiritual and moral values and that honesty was always the best policy in our pursuit of life, love and happiness.

They always took great pride in each of our accomplishments whether large or small, while not overlooking our faults and failures. Even when we made mistakes, which all kids do, we knew we were not abandoned. Mom and dad were always there for us!

As my seventeenth year began to wind down three major happenings loomed great on my horizon: two I knew about, the third was a total and complete surprise!

The first big happening was my birthday. In a very short period I was going to celebrate my eighteenth birthday, and shortly thereafter I was going to graduate. These were two monumental steps in my life. One came just by staying alive while the other represented a lot of years of hard work. I was ready for both!

*Eighteen and out of school!*
*Footloose-and-fancy-free!*

What more could a girl ask for than to be eighteen, out of school and footloose-and-fancy-free all at the same time?

Wait! Stop the tape! Didn't I say there were three major happenings on my horizon? The third one was by far the biggest and most important of all!

Here is how it happened!

My mom and Teresa were out on a shopping spree with one of Teresa's girlfriends. As they started into a store my mom got sidetracked by a sign that had something to do with a mission's project to help underprivileged children. Anyone who knew anything about Imogene Jackson was aware of her intense love for children, especially teenagers.

While Teresa and her friend shopped, mom was busy learning everything she could about the children. All too soon the girls finished shopping and came to retrieve mom who by now was totally enchanted with the teen she was talking to.

As she turned to leave mom looked back and said, "Young man, how old are you?"

"Seventeen," he answered.

"Oh, I have a seventeen-year-old daughter! Here let me show you a picture of her!"

She showed him a picture of me in my cheerleader's uniform and he remarked that I couldn't be a Christian dressed like that.

Mom replied, "Oh yes she is; call and talk to her yourself."

I couldn't believe mom would give this guy my phone number.

That evening I received a phone call from a young man named Cedric!

Before I tell you about our conversation that evening let's hear Cedric's thoughts about the woman he met in the parking lot.

> Since I was on a mission trip to raise awareness of the plight of underprivileged children I was happy for anyone to stop and talk to me. This woman, however, was extraordinary.
>
> First of all, she asked great questions and apparently had some knowledge about God, but according to my religious upbringing she didn't dress the part.
>
> I don't mean that she was not properly dressed. She looked very nice, her clothes were neat and clean, but she was wearing slacks, lipstick and earrings. In the church I came from that was totally unacceptable attire. We were taught that a "real" Christian lady would never wear a pair of pants and if a woman wore lipstick she was referred to as "Jezebel."
>
> Yet, in spite of the way she looked to my prejudiced eyes, there was something so genuine about Mrs. Jackson that I wanted to know more about her and her family. Of

course since she had a seventeen-year-old daughter, what could I lose by calling?

## Destiny in a phone call!

Mom came home and told me about meeting a nice young man and that she had given him our phone number. So when Cedric called I was not too surprised. He sounded okay and we found plenty to talk about. That's not too unusual; ever since Alexander Graham Bell invented the telephone kids have always found something to talk about. Tying up the phone lines with teen chatter is as normal as the sun coming up in the east.

Cedric called the next morning and again our conversation was very easy. We seemed to have a lot in common. We were both Christians so that gave us a head start on liking one another. By the end of the second day I knew I liked him and looked forward to his next call.

On the third day there was nothing unusual about our conversation. It started like most teen's talk, "What's happening? Are you doing anything special today?" Ours was the type of talkfest that most parents consider trivial drivel! It didn't remain that way, however; before the day was over the conversation was serious.

*Everyone dreams of meeting Mr. or Miss "Right"
and above all they hope
his or her first name is not "Always!"*

Although I had never given a lot of thought to it, I suppose I was hoping to some day meet "Mr. Right." But it wasn't something that concerned me at seventeen so when Cedric told me he loved me, it took me by surprise. The first time he said it, all I could say was, "Thank you!"

Have I told you yet that our only communication was over the phone? We had not met in person, and it was only our third day of talking when he said the magic words every girl wants to hear.

On that third day we made a commitment to each other. We would be faithful to each other until he could finish his mission assignment in Alabama and get back to Denver.

I remember hanging up the phone and going into the room where my mom and dad were. I told them that Cedric had told me he loved me, and that I believed I was in love with him too.

I have to tell you my dad wasn't at all happy with that sort of talk. I'm sure he thought it was just "puppy love," but what he didn't realize was that it was real to the puppies!

Mom didn't seem too disturbed with my announcement, but keep in mind she had met

him. All I had done was talk to him on the phone, and all dad knew was that he was of the male species and wanted to take his baby daughter away.

That night when we hung up the phone we were both heavy of heart because Cedric had to leave for Alabama the next morning.

*Terri & Cedric at 17*

## Out of sight, but not out of mind!

The person who wrote, "Parting is such sweet sorrow," was out of his mind as far as we were concerned! There was nothing sweet about those final moments on the phone. We each believed we had found the love of our life and so quickly we were going to be separated by hundreds of miles and several state lines.

Could such a budding romance endure the hardship of a protracted separation? Could two young kids withstand the temptations so common to youth their age? Was it possible that they had made a true life commitment or were they simply infatuated with each other?

There is an old saying, "Out of sight, out of mind," but that certainly didn't fit us. The miles, hours, days, weeks and months could not extinguish the flame we felt in our hearts. If anything, "Absence made the hearts grow fonder!" I remember listening to Cedric's voice mails on my phone every single night before I went to bed and Cedric would listen to a music CD of me singing to him every day and night.

The months we were apart gave me time to put things into perspective. Was I ready to have a steady boyfriend, ready to be engaged? Was it the right time to start planning for marriage? Did I know enough about this person to make a pledge that would bind me for the rest of my life?

What if he rejected me because of my weight? What if he wasn't attractive to me once we met? What if…what if…what if? So many questions and no real answers! After all we hadn't even seen each other yet.

**Was Cedric the fabled "Mr. Right" for me?**

Chapter Five

## Wedding Bells and a White Gown

Not long after I celebrated my eighteenth birthday I was walking across the stage accepting my diploma and saying goodbye to my alma mater.

Once school was out I wanted a different job. The part-time position I had didn't pay enough so I became a salesperson at Burlington Coat Factory.

*Terri singing at graduation*

That summer was not anything like I had anticipated. I thought once I was out of school

the whole world would be different. After all I was now an adult (well almost) and I would be looking at everything from an adult perspective. The shocking truth was, I was now expected to get up every morning and go to work because that was what the adult world did.

Thankfully, I was able to adjust to my new routine which helped May, June and July pass quickly. Since I was not a party-girl my evenings were spent either with church activities or on the phone with Cedric as often and for as long as we could afford the charges.

When Cedric left to go back to Alabama we thought we would be apart from each other for a year, but the loneliness was too great for either of us so in August he returned to Denver.

## *The first time we laid eyes on each other!*

I'm not sure I have words to express the emotions I felt when I knew he was coming back. We had never seen each other. Our only contact had been via the phone and, even though I thought I knew him, I didn't know what to expect.

I don't ever recall questioning whether he was the one for me, but the thought crossed my mind: what if, when he saw me, he decided I was not the one for him.

For all those years I had fought with my weight and had nothing to show for it but a few battle scars and plenty of fat. Now I was facing the most crucial hour of my life. I was aware that my one and only love could be turned off by my size and I was helpless to do anything about it.

All my fears vanished into the thin Denver air the moment we met. He was everything I had imagined him to be and even more. He was not only my prince charming but he was handsome, kind and considerate as well.

The next few months were as exciting as a ride on a giant rollercoaster, yet as peaceful as a mountain lake without a breeze. Cedric moved in with Teresa and her husband, Carlton, and I continued to live at home with my parents. We saw each other as much as we could after work, and church was a vital part of our weekends. Mom and I had to re-educate Cedric that it was okay for a godly woman to wear pants, make-up and jewelry. I must admit he was not a reluctant student.

The living arrangements were fine until Teresa and Carlton had some financial reverses and had to move back in with our parents, which meant Cedric was coming to live with us also.

I don't mind telling you my mom had major problems with that. Her words were, "I don't want it looking like the two of you are 'shacking

up' in my home." Mom was as serious as a heart attack about her faith and she didn't want to give the impression that she condoned sex before marriage.

## *An unlikely thing happened after our Bible study!*

Our wedding plans were all set for June 23, 1993, but with the new living conditions we were forced to make some adjustments. So in January of 1993 we exchanged our vows. I didn't say we got married; I said we exchanged our vows.

Here's what happened!

We explained our dilemma to our dear minister friend, the late Reverend Thomas Palmer, after Bible Study at the church where we were meeting. Cedric told him we wanted to exchange our vows but not have the wedding until June.

The old preacher's eyes twinkled as he drew from his many years of experience. "So, you want to exchange your vows now," he said, "because you think that will stop anyone from having anything derogatory to say about you, but keep yourselves pure until your wedding day in June? I think you have a wonderful plan and if you are ready we can do the vows tonight!"

The exchanging of vows didn't change anything as far as we were concerned. When we went home that night I went to my bedroom upstairs and Cedric went to his in the basement. We didn't consider ourselves married. We had simply exchanged our vows so that Cedric could legally live in my parent's home.

In today's society a woman can get married to her fourth husband in a white gown, but to me a white gown was reserved for a virgin. And I was determined I would walk the aisle of the church in a white wedding gown.

*A June wedding in a white gown!*

Not only was I a virgin on our wedding day, Cedric had kept himself pure for me as well.

After our beautiful ceremony was over and we were alone at last. It was time for us to consummate our vows and become husband and wife. I said to him, "Do you suppose we could wait one more day before we do what we're supposed to do?"

He had the most incredulous look on his face. It was as if he was saying, "You want to what? I've been waiting for this moment all my life and you want to wait another day? Tell me you're kidding!"

It wasn't that I didn't love and desire him; the truth is I had never been so scared in my whole life.

Two kids out to conquer the world armed with nothing but faith in God and love for each other. How far could love and faith take us? That remains to be seen because we are still together, still faithful to each other, still as much in love as we were the day we made our commitment in 1992 and our faith in God is still intact.

*Terri's helpful sisters, Teresa & Vicki*

*Teresa, Terri, Carlton & Cedric*

*Ms. Jones offering help*

Marriage was everything I had ever hoped for. I loved being Mrs. Cedric Lipsey, I loved working in the church, and I was almost content except for one nagging problem—FAT!

Several years after we were married I asked Cedric if my weight bothered him the first time he saw me. He admitted it did, but he thought he could help me control it. Nothing could have been further from the truth. Regardless of what we tried to do the pounds continued to add up year by year by year until it was affecting my health as well as my emotions.

What effect does the gene structure have on an individual? We know that alcoholism runs in families and is passed down from generation to generation. Medical science says the same is true for other disorders such as heart conditions, cancer, diabetes and other common maladies. Even though I refused to attribute my overweight condition to heredity alone I am certain that it had a great deal to do with it.

My maternal grandmother died giving birth to her fifth child when she was only 39 years old. She had diabetes and fat around her heart. Both she and the baby died. Her diabetes was brought on because of obesity. Her mother, my great-grandmother, died because of heart failure and diabetes. She was also overweight!

My mom also battled her weight from the time she was a young girl and throughout her

adulthood. So part of my problem was definitely in my genes.

## *Married life agreed with me!*

I had a weight problem growing up but it was nothing in comparison to what I experienced after we were married. I loved every part of being a good wife: cooking, housekeeping, doing the wash and all of the little things that went into taking care of my man. Married life really agreed with me and my contentment showed up in the amount of weight I was gaining.

Even though he tried to help, all my poor husband could do was stand by and watch as I ballooned bigger and bigger.

I have to give him credit for continuing to love and affirm me through those horrible days when the weight gain was totally uncontrollable. Again, it wasn't that we gave up, because we didn't! We continued to try every diet we heard or read about. In our desperation we tried everything from fasting to drinking liquid shakes and lots of water. I drank enough water to float a battleship.

I even went on a 21-day fast in an attempt to starve the pounds away. I remember hoping against hope that one day I would wake up and find that all the unwanted fat had simply

disappeared, but fasting didn't make it go away. However I did prove to myself that my obesity was not due to the lack of willpower. It took a lot of inward strength to go without food for 21 days.

We tried walking, (running was out of the question) going to the gym, saunas, steam rooms, plastic wraps and hot tubs but everything we did made me hungry, which made me eat, which made me fatter. It was an endless cycle!

Even though I was free to go wherever I chose I was as much a prisoner as if I had been locked behind bars. I was a prisoner of an insatiable appetite and it seemed as if everything I ate turned to fat.

If I had not loved Cedric so much I could have wished myself dead. I was disillusioned with trying to lose weight because every time I tried a diet I invariably gained back more pounds than I lost. I began to hate every mirror because the person I saw was not who I wanted to be.

*Terri at 20*

Why couldn't I go on a diet and lose fifty, sixty or seventy pounds like the women did on the TV commercials? Why couldn't I take a

55

magic pill that would melt the fat off and leave a beautiful figure in place of the unsightly rolls? Why couldn't I just go to sleep and wake up slim and trim?  Why?  Because I had been obese for so long that my body wouldn't budge.

*Losing weight was not my problem— keeping it off was!*

Losing weight was not my problem.  Over the years I had lost hundreds and hundreds of pounds—keeping it off was my weakness! I thought of having my jaws wired together, but I was afraid that as soon as the wires were removed I would be on my way to an even greater weight gain than before.

I read about people having their stomachs stapled but I didn't think that would work for me. I could see myself popping the staples loose. Year after year I was able to find different excuses for not taking drastic measures; meanwhile my weight continued to increase.

Maybe what I needed was to get pregnant! After all if I got pregnant it would no doubt help me control my diet better because I would be careful to only eat the foods that would produce a healthy baby.

Cedric was not delighted with the idea of us having a baby; he came from a very large family

(12 children) and had never wanted children. He finally agreed but neither of us was prepared for the heartbreak we encountered.

Shortly after reaching the decision to have a baby I was rushed to the hospital with a severe pain in the abdomen. The doctor informed us that I was pregnant. Unfortunately, it was a tubal pregnancy and our baby did not live.

Both Cedric and I were terribly disappointed over the loss of our first child. It seemed as if the fickle finger of fate was fouling everything we wanted to accomplish.

At that point we could have easily allowed our faith to be overrun by fear, and our hopes to be dashed against the rocks of discouragement but we didn't.

Let me remind you of the earlier statement: "Survivors only survive. Winners win!" Even though we experienced the tragic loss of our first child we were willing to face potential heartache and try again!

The next pregnancy was a breeze. I carried our second baby full-term and delivered a healthy baby boy. We named him LéVertis. But pregnancy did not cure my obesity, if anything it made it worse. Was there any help for me? Would I ever find the answer to my problem?

### *Was I destined to be fat forever?*

## Chapter Six

## *I'm Coming Out*

Like most women, I gained a lot of weight during my pregnancy. I undoubtedly bought into the old folklore that I was eating for two. The second one, however, did not need as much as I was eating for him.

My body knew what to do with all the excess food I was giving it—deposit it in the various "fat banks" I had established through the years.

By the time I went to the delivery room I was tipping the scales at more than three hundred pounds. My five-foot-eight-inch frame was groaning beneath that much weight, especially my feet and legs.

How could I allow myself to get so out of control? My best explanation is that of a snow

ball rolling down a mountainside, the farther it rolls the bigger it gets and the faster it moves. I had reached the point of no restraint.

Was I concerned? Yes! I didn't like what I had become. I didn't like the way I looked or the way I felt. I wasn't happy with myself but the more despondent I became, the more I ate and the more I ate, the more I gained. My snowball theory was more like an avalanche; it was destructive and totally out of control. My only question was: how could I get off this terrible merry-go-round that was killing me?

I remember going to a doctor with pain in my feet and legs. He wanted to give me a series of shots in my feet and another procedure. It was obvious to me that my problem was not with my feet but with everything above my ankles. My poor feet were groaning from the weight they were being forced to carry.

*Terri during pregnancy & Cedric*

*Decisions determine destiny!*

Again, decisions determine destiny. My destiny was being determined by an eating disorder, which I had to change. It was a

decision that only I could make. I came to the startling reality that unless I received help from an outside source I would continue to eat myself to death.

It isn't easy to make this confession but perhaps it will help another individual in the same condition realize that an eating disorder is as deadly as drinking or drugs. Compulsive eating is as much a sickness as any other addiction. I was addicted to food, especially junk food!

I had kidded myself, or better yet, I had lied to myself through the years that if I really wanted to, I could lose weight. God knows I had had enough practice with all the diets I had tried. By this juncture in life I had successfully lost several hundred, maybe even a thousand pounds. I was capable of losing enormous amounts of weight—keeping it off was my problem.

I laughingly told you about being the "Princess of the yo-yo diet world," what I didn't tell you was that I became the "Queen" of the same yo-yo world when I was an adult. I was always looking for and trying another diet. It didn't really matter to me if it was a fad, a magic pill, in a can or something I had to mix or shake up I was willing to try it. The net results were always the same, lose some, gain more!

Not long after we were married Cedric and I became the pastors of a new church in Denver. Since it was new and small I continued to work

to help with our finances. I remember so vividly the time some young women who were in our wedding taunted me about my weight telling me they could steal my husband because I was too fat for him to really love and care about me. (No, I didn't slap them or drown them in the baptistery!) Thankfully, Cedric was not promiscuous. He remained faithful to me through those dark and dreadful times.

My self-image wasn't just bad, it was in the pits. I was so distraught I thought I hated myself. There were times when I wished that Cedric would have an affair because I was so unattractive. I had tried everything I knew to do and nothing worked for me. At that time we didn't realize that I had a genetic problem and dieting alone could never cure it.

*Agony with de-feet and the agony of defeat.*

I was living with physical agony in "de-feet" and the emotional agony of defeat. The physical and emotional drain was too much. Something drastic had to be done!

After the 9/11 tragedy I became an independent contractor for the U.S. Homeland Security. My job was to teach and train airport personnel how to screen passengers and

promote airline safety. At that time I was big enough that no one gave me any lip. The sad truth was no one knew how terrible I felt or the conflict that was going on in my heart.

Eventually Cedric joined me as a part of the team. Our travel schedule made it difficult for him to continue as the pastor of our little church, which I'm sure was an inner battle for him. The small amount they paid him was not enough to sustain our growing family so he made the decision to leave the pastorate. That set us on the path of becoming successful entrepreneurs.

## Divine intervention!

With our travel and work schedules it wasn't very often that I had the luxury to watch TV in the afternoon, not that I was all that interested in what was on the tube in the first place. One day I was afforded a rare opportunity to sit down and relax with the one program I really did enjoy—"**The Oprah Winfrey Show**."

Oprah had as her guest Randy Jackson, one of the celebrity hosts from American Idol. Randy was talking about a proven method for losing weight and keeping it off the rest of your life.

I thought to myself, "This has to be divine intervention! Only God could arrange my busy

schedule in such a fashion that I can hear what this man has to say." I was all ears!

I remember someone saying: "This procedure is not for everyone!"

I said to myself, "I'm not everyone; I'm Terri Lipsey. If it can help me lose this weight and keep it off, then it's for me!"

As Randy talked about the procedure I understood why it was not for everyone. There are many risks involved and the possibility of major complications was enough to scare off anyone who was not sick and tired of carrying a hundred or more pounds of excess baggage.

In my teen years I envisioned a shapely young lady inside me trying to get out. As a wife and mom it was a mature lady trying to do the same!

## *Throwing caution to the wind!*

For me to do what was being described on TV was tantamount to throwing caution to the wind! Earlier I said that it was time for something drastic to happen. Conventional weight-loss methods simply had not worked for me. I had tried everything in the books for almost twenty years and I knew it would take more to get me off the "fat farm" and into mainstream America.

After hearing Randy talk about his experience and seeing how great he looked, I made up my mind that it was something I had to do!

You can be assured I didn't watch that one show and run out to schedule the doctor and hospital, I did a thorough study. I admit the more I checked into the procedure the less I wanted to do it, but I had to for my health's sake.

With my weight above 290 pounds and still going up, I was afraid my heart would eventually explode. Added to that fear was the probability that I would become a diabetic like my mom and grandmother, before her untimely death at age 39, or that I would lose the use of my feet and legs.

*Terri before surgery with Cedric and LeVertis*

Cedric, my wonderful husband, was also deeply concerned about my condition. When I told him about the procedure he became as involved as I was in learning everything he could.

It was hard for him to give his unconditional approval since it could have left him a widower with a motherless young child to nurture and care for alone if anything went wrong on the operating table. But he also knew that I was

eating myself to death and something had to be done.

## Did I say operating table?

Never in my wildest dreams did I imagine that it would take something as drastic as surgery to help me lose weight and keep it off!

Thousands of men and women have lost a lot of fat and remained slim and trim by attending the meetings and following the Weight Watchers Program of counting calories. Thousands more have successfully lost unwanted pounds and maintained their optimal size with the Atkins Plan or by any of the other proven methods. But, for whatever reason, I was not successful with any of those. I had to have help; the operating table was my next option.

Before I list some of the many problems that can go wrong in the procedure let me give a word of encouragement to those who are contemplating the same or a different type of surgery. Get the best medical advice possible; keeping in mind that one procedure may work better for you than another. Your heart may not allow you to undergo the treatment I chose but that's not the end of the world. Find a good medical doctor who is a weight loss specialist.

Please notice, I said a MEDICAL DOCTOR! There are all kinds of doctors. Simply because a man or woman has a degree that gives them the right to be called "doctor" does not mean he or she is qualified to give you advice on how to safely lose weight.

*One of the surest ways to make a million dollars today is to hang up a "Lose Weight" sign and have a doctor's name on it!*

In the Wild West bogus practitioners were called "snake oil" salesmen. They had the cure for anything that ailed you. To hear them talk, their lotion, potion or liniment could heal everything from a broken heart to a wart on your big toe. Some of those fast-talking city-slickers could make you believe their tonic would grow hair on a brass doorknob!

Today's "snake oil" salespeople appear on your TV screen telling you that all you need to do is take one little pill to melt the fat right off your body no matter how much you eat. Then they show you a beautiful model with the before and after pictures that are absolute proof that if you buy one bottle of their magic potion you will be as thin as twiggy in just thirty days. If you are struggling with your weight don't fall for their spiel!

I know what it's like to be big around the middle, broad across the rump and to have thighs like oak trees. I know how lonely you feel when you are larger than any of your friends and you would rather die than go out in public. I know the emotional pain you are going through and that's why I encourage you to seek true professional help.

I know what it's like to hide behind the curtains in your home and cry from the misery and pain you are going through. I know what it's like to put on jeans and leave them unzipped because they are too small. I'd wear a sweater or a baggy shirt and pull it down over the open zipper and hope that no one could tell.

After discussing with a friend the trauma we went through being fat we agreed that it is one of the worst things that can happen to a person. Many times I wished I were a drug addict or an alcoholic, anything but fat. I can't tell you how many times I've looked through the restaurant windows to see if the booths were large enough to accommodate me or how many times my poor husband would sit on the opposite side of the table with it shoved against his chest just so I could sit down.

You are not the only person who has had to endure the snide remarks of the uncaring public as you walked down the street, got on a bus or went to a ball game. I'm telling you that there

is a better life than you are living. There is a silver lining to your cloud and a pot of gold at the end of your rainbow!

Just as one size **does not** fit everyone, one procedure is not right for every **body**. You owe it to yourself to meet with your doctor and find the one that's right for you! Remember, whatever it takes—**You are worth it**!

Having said that let me give you a partial list of the complications, which could occur from the surgical process we chose for me:

| | |
|---|---|
| Bleeding during or after surgery | |
| Gallstones | Pneumonia |
| Cardiac problems | Leaks |
| Nausea and vomiting | Infections |
| Pulmonary embolus | Cancer |
| Deep vein thrombosis | Hernia |
| Bowel obstruction | Stricture |
| Ulcer in the pouch | |

*For anyone thinking this is the easy way out— think again!*

You are, no doubt, asking why I would choose a procedure that had all these negatives. Let me remind you I didn't say all these things will happen, I said they can. I am thankful I experienced only the nausea and vomiting!

When we finished our detailed, fact-finding mission we were ready to find the right doctor

and get the show on the road.

From the time I was six years old I had known the rigors of being fat. Throughout my life I had endured the teasing, taunts and torments of friends and foes. I had been razzed, reviled and ridiculed, despised, disparaged and dumped on—but not any more!

I was sick and tired of not being able to tie my own shoes or get on the floor to play with my baby. No longer would I hide the hurts, mask the pain and make excuses. I was ready to take life by the horns!

*Enough was enough!*

I had made up my mind that inside all that fat was a beautiful, thin, shapely Terri Lipsey ready to come out and start living life to its fullest!

Chapter Seven

*One Life to Live*

Party Time! My mom and Teresa decided to throw a going away party for the Terri who had occupied my body for so long and a welcoming party for the beautiful butterfly who was about to emerge from the shapeless encasement.

It was time for celebration and jubilation because I was about to enter into a brand new life with a brand new body.

I don't mean to give the impression that I went into the hospital weighing 300 pounds and came out weighing 136. The doctors were not going to hook up hoses and suck the fat off my hips, thighs and around my middle even though several people have tried that procedure. Rather they were going to replace my large stretched out stomach with a very small one.

When I say small I mean tiny enough that only one ounce of food would fill me up. My new stomach would be about the size of a small chicken egg.

Let me put an ounce into perspective for you!

One ounce is a can of soda divided into twelve parts. For some people that's less than one swig. It's the patty of a McDonald's Quarter Pounder cut into four pieces—not the whole hamburger; bun, pickles, lettuce, tomato, ketchup and mayo—just the patty cut into fourths! It's one-sixth of a petite fillet from Outback Steakhouse.

*One ounce is not a lot of food!*

Doctors encourage adults to drink eight glasses of water each day. Since a glass is eight to twelve ounces, that would be equal to filling me up somewhere between sixty-four and ninety-six times a day. Whether it was water or food, all my new stomach would hold was one ounce. Believe me, one ounce is not a lot of food!

When I considered the meager amount I would be able to eat compared to what I normally ate, it was evident that all my life I had consumed far too much food at any given meal. My daily consumption coupled with my genetic problem spelled catastrophe from my childhood.

*I decided that food would no longer rule my life!*

Prior to making the decision that food would no longer rule my life I didn't eat to live, I lived to eat! Food was more than a necessity, it was my security. It had become my best friend. As sad as it may sound, I was in love with food. I could count on it to help me through the rough spots in life; it was my comforter when things went wrong. Regardless of what others said and did to me, my friend—food—was always there to help me pick up the pieces of my broken heart and go on. What I didn't realize at the time was that I was a prisoner to the comfort I found in food!

*Prison break!*

Thank God, I finally had the courage to break out of my self-imposed prison and get the medical help I needed! I promise it was not one day too soon.

Saying goodbye to the old Terri at the party was like losing a dear friend. Terri had been good for a lot of laughs. Over the years she had endured so many jokes about being fat that everyone thought she was immune to anything they could say.

73

I knew her better than anyone and I can tell you that she never got so thick-skinned that the barbs didn't penetrate and hurt deep inside. She may have laughed at the cutesy remarks but the pain was there none-the-less.

When the uproarious laughter of the last fat joke died down and everyone had said their final farewells to the old girl, all the attention was turned to the arrival of the new Terri.

To be honest no one knew what to expect because all they had ever seen was the big fat Terri. I'm not sure anyone except me could envision the beautiful lady that was ready to take center stage. I knew what she would look like because I had been dreaming of her for years and I knew that someday, somehow, somewhere she would become visible for all the world to see.

One of the favorite tourist attractions in Bangkok, Thailand is the temple of the golden Buddha. The temple itself is not the attraction but what it contains and the story behind it.

Years ago when Thailand was the Kingdom of Siam, the country was being invaded by a neighboring army. As the invaders drew closer to the city a group of monks, fearing their precious golden Buddha would be stolen and carried away, covered the entire image with a thick coat of clay.

In the ensuing battle all of the monks were killed, but the invaders saw no value in a clay Buddha so they left it.

As the years passed new generations of monks were the caretakers of the clay Buddha. One night during a heavy rainstorm one monk took a flashlight and went into the unpretentious temple to check for leaks in the roof and cover the clay idol.

As he carefully inspected the statue the beam of light revealed a small crack in the clay and reflected a glint of light back at him.

Intrigued by what he saw, the monk carefully removed a small portion of the cracked clay and discovered what looked to be gold. He worked throughout the night carefully removing more and more of the clay veneer. When he finished what he had was the solid gold Buddha that thousands of tourists visit annually.

Like the golden Buddha encased in clay, I knew that inside of me there was a beautiful lady encased in fat. All we had to do was remove the outer layers to reveal the true person.

One of the gifts I received at the party was a pair of bikini panties. When I saw them I burst out laughing. If the old Terri had tried to wear bikinis the tiny straps would have looked like strings around a bale of cotton.

My emotions were running high at the party; I knew that a new world was awaiting me when I exited the operating room. I had counted the days and, regardless of the pain or suffering I might experience, I was ready at last to begin my journey from "Fat City" to "Thinland!"

*Terri at the going away party*

As much as I wanted to go through with the surgery and begin my new life it was not totally my decision. I was also a wife and a mom and I valued my husband's opinion, after all, if anything went wrong during the procedure he could be left to raise our son alone or care for an invalid wife.

Cedric shared his thoughts and apprehensions regarding the procedure and the impact it would make on our marriage in the following statement.

*Cedric and LéVertis*

I fell in love with Terri before I ever saw her! She had a sweet spirit that melted my heart the first time we talked. Later when we actually met in person I knew I had made the right decision

and wanted her to be my wife.

I admit, if I had not been in love with her, the weight would have been a turn-off to me, but I believed I could help her lose the excess pounds.

At the time neither of us knew her weight problem was far deeper than the quantity or kind of foods she ate. She was a victim of a genetic disorder that had been prevalent in her family for many generations.

Regardless of how hard she worked to lose the fat it simply refused to go and stay gone. We tried every imaginable diet; she even fasted for 21 days in a Herculean effort to slim down. Yet with all the disappointments she never stopped trying. Each time she heard of another diet plan she was ready to try again.

Had I been the one trying to lose weight I would have given up after the first fifty failures but not Terri, she had determination like a bull dog; there was absolutely no quit in her.

I remember when she told me about seeing Randy Jackson on TV and how much weight he had lost. She was excited that at last she had found a way to conquer her life-long enemy. Then she explained how the surgical process worked.

She was so excited. I really didn't want to dash her hopes even though it was hard for me to feel the same enthusiasm she felt. The thought never occurred to me that I wasn't the one who had fought and lost the fat war all of those years.

I reluctantly agreed to learn everything I could about the procedure before I voted against it.

The more I learned the more favorable I became for her to have the surgery.

My first concern was for her safety. I wanted to make sure the surgeon she selected had successfully performed the procedure several times. I certainly did not want her to be a guinea pig on the operating table.

The second concern was the cleanliness of the hospital. I'm sure you have visited hospitals that just didn't feel clean. I didn't want her in one of those.

When Terri assured me the doctor was one of Denver's finest and the procedure was being done at Rose Medical Center I agreed to her having it done.

However, agreeing to the surgery and being excited about it were two different things. I really had mixed emotions. What would I do if something went wrong? What if her overweight condition had weakened her

heart so much that she couldn't survive the anesthetic? We had an infant son; was I doing him an injustice by agreeing to let his mother have the surgery?

As you can see I had plenty of questions and no one to give the answers. In the end it was a matter of choosing the possibility of losing Terri during the procedure or watching a sickness continue to destroy her.

At that point my negative thoughts were not allowing me to see her emerge from the operating room with a bright and wonderful future. Fear had me in its grip and all I could see was the lesser of two evils.

Thank God the procedure was a success and I have a wife with a life and our son has a mother who can interact with him!

Psychologically Terri's weight problem gave me a decided emotional advantage! The mental image she had of herself due to her size had destroyed her self-confidence. She had, in many ways, become dependent on me which gave me

*LéVertis, Terri & Cedric riding Shamu at Sea World*

unquestioned power and authority. I'm not saying she didn't have her own opinions or that she was afraid to speak her mind because Terri has always been assertive. I could have used her weight as a tool against her had I chosen to do so.

As her husband I saw the daily battles she fought with low self-esteem. I heard the groans for freedom from the shackles that had bound her. It's too bad I didn't understand that many of our disagreements were not about me. Rather, they were from the torment she experienced from being fat and feeling unattractive.

Saying yes to the surgical procedure was a shot in the dark as far as I was concerned but it was something I had to do for her sake.

Am I happy that she had the surgery? A million times YES! I no longer have a self-deflating wife who would rather be dead than alive. The new Terri walks with an air of confidence that says, "Look at me, I am a person of value!"

**The change is miraculous!**

*(Cedric)*

Finally, at the party when I opened the box from my mom I couldn't believe my eyes. Inside was a skimpy Daisy Duke outfit. Not that she ever wanted me to show that much skin, it was

her way of saying I would someday be as slim and trim as a model.

**Turn out the lights; the party's over!**

## Chapter Eight

## *Breaking Up is Hard to Do*

What's so hard about breaking up? In most instances a break-up is due to a major difference in opinions. When it involves lovers it's because one or both parties are simply disinterested or that one becomes unfaithful!

In my case it was a mixture of all the above! My love and I had a major difference of opinions, so much so that the break-up was irreconcilable. We were going in opposite directions forever. I'm the guilty one in this break-up! I became so disinterested and unfaithful that I didn't want anything to do with my love ever again.

Wait, before you draw the wrong conclusion, let me make it clear that I'm not talking about breaking up or being unfaithful to my darling husband Cedric! We are more than husband

and wife; we are soul mates, best friends, lovers and companions.

The break-up I am referring to was my love for food. As a young child I fell in love with food, especially junk food. Little did I know that my ardent love for food was being fueled by a genetic problem that had been hanging around in our family circle for several generations.

The genetic malfunction worked like a plague against my mom, grandmother, great-grandmother and me. We each thought we were fat because we overate and for the most part we did but that was just part of the problem. The genetic misalignment in our systems didn't allow us to burn the fat in our diet. Instead it collected and stored every fat molecule it could get its greedy little hands on.

Regardless of how hard I tried to lose weight it was all in vain. All I ever lost was fluid, my genes locked up the fat and wouldn't let it go! As soon as I replenished the lost fluids I was right back where I started. In the meantime fat continued to be stored all over my body.

I know it will sound bad but truth is truth; food and I had been friends and lovers since I was a child. I learned early in life to lean on it. It comforted me when other children poked fun and called me fatty. As I grew older it was always near by to console me with its pleasing aroma and good taste.

Breaking up meant I had to force my body to change its course and become a fat burner rather than a fat collector. To accomplish that fete I needed professional help.

While watching the Oprah Winfrey Show I was introduced to the Roux-en-Y gastric bypass surgery. This is a procedure where the doctor uses a medical stapler to make a small pouch (about the size of an egg) at the top part of the stomach. The rest of the stomach is not removed but stapled shut at the top so food no longer enters that portion but remains connected to the small bowel below. The stapled portion of the stomach continues to create acids that mix with pancreatic juices and bile from the gallbladder and flow through the lower bowel. These acids are necessary for the breakdown of foods in the gastrointestinal tract.

Since I'm not a medical doctor I'll not elaborate on the technical side of the surgery. I chose to have the laparoscopic procedure which consists of six small openings on the abdomen rather than a four to seven inch incision.

The moment the nurses wheeled me into the operating room I knew I would no longer be a prisoner to food. Rather than food being able to elevate me to a false comfort-zone it would be forever relegated to its rightful place in my life—I would simply eat to live, rather than living to eat!

I had every right to hate being fat! Throughout the years it had made me the butt of cruel jokes, the laughingstock in school, an object of scorn in restaurants and other public places and the victim of prejudice.

From the time I was a kid I endured the cruel, crude and sometimes vulgar jokes and tried to act as if it didn't bother me but the pain was like a knife inside me.

I was so happy to be a cheerleader in high school that I tried not to notice that they always put me as the base (that's the girl at the bottom of the stack) when we made a pyramid. It wasn't that I wanted to be the girl at the top, I knew I was too fat for that, but still it hurt when the kids made fun of my size.

In restaurants people looked at me as if to say I didn't need to eat again for the next

year. When I went to public places such as arena football games I had trouble fitting in the seats.

I remember sitting on a plane by a window and when the passenger sat down next to me he forced the armrest down between us. It was as if he was making me fit in a seat that was much too small. I'm sure he was disgusted with having to sit next to me as big as I was. What he didn't know was that I hated being fat more than he did.

Several times when I flew across the country as soon as I boarded the plane I would quickly find a blanket, pull it across my body and hold my breath, hoping the flight attendant didn't notice that my seatbelt was not fastened. I was embarrassed to tell them it wasn't long enough to fit across me.

What was even more embarrassing was when a flight attendant would bring a seatbelt extension, which was like announcing to everyone on the plane that I was too fat for the seatbelt to fasten.

I applied to become a flight attendant with a large Denver-based airline. I thought the interview went very well. I was not easily intimidated so when I went for an interview I always came across as being confident. I was fat but that didn't keep me from being bright and articulate.

After the interview my friend who worked for the airline called me. When I asked if I was being considered for the position she said, "Terri, they said you were way too big!" Obviously when I received my rejection letter in the mail it didn't say anything about me being too big.

All of my life I had suffered the anguish that goes along with being fat. Once in school I remember sitting on the counter in the girl's restroom and it broke the sink. I was only in the seventh grade.

When I went swimming I would wait for the pool to clear out before getting out of the water.

I have told you some of the horrible things that happened to me but I don't want you to think that life was without its funny times as well. Even though I was as big as a house and hated being fat as much as any human ever hated it, I had fun because I refused to crawl off into a corner and die.

*Everything in life was not morbid!*

I hesitate to share one funny incident that our family still laughs about. Cedric and I had a waterbed in the master suite of our home. One night Cedric and LéVertis were lying on the bed playing a game and I thought it would be fun to

do a belly flop on the bed and join them. When I hit the bed it created a tidal wave that tossed LéVertis out of bed, into the air and onto the floor.

It is hilarious, looking back now, seeing him fly through the air but at that moment it was mortifying. I thanked God that he escaped injury but I admit my low self-esteem suffered another blow from that incident.

The people in an individual's life can help to make it happy or they can contribute to the sadness. I had two wonderful people in mine who helped me more than I can ever put into words: my sister Teresa and her husband Carlton.

Teresa influenced my life as a kid and also as a teenager but it didn't stop when I grew up. She has always been ready to help me with any struggle I've faced.

When she married Carlton I didn't lose a wonderful sister, I gained a superman for a brother-in-law. Carlton has remained one of my staunchest supporters throughout my trials and tribulations. I will always love and appreciate Carlton for his help and guidance.

*Carlton & Teresa*

89

When I was ten years old Teresa and Carlton were blessed with a beautiful daughter, Tereka. Tereka was almost a carbon copy of me when I was little, following me around just like I had followed Teresa and Steve. She went everywhere with me, to school functions, ball games and special outings. The one thing she didn't do was have her candy concession going like I did at that age.

*Carlton, Teresa & Tereka*

"**Breaking up is hard to do**!" especially for those who want to hang on to the things that made them fat in the first place. Some who have had their stomachs stapled shut have somehow managed to force-feed themselves until they were back to the same weight they were before surgery.

Breaking up was not a difficult decision for me. I hated everything about being fat! The way I looked and felt physically and emotionally. I despised the taunts, slurs and pain it inflicted on me. I detested wearing a girdle that fit so tight it caused the skin around my belly button to break.

*I don't miss feeling like an outcast, lonely and unworthy!*

Breaking up may have been hard for all of those fat genes running loose in my body but it wasn't hard for me to say goodbye! My whole life had been lived with the trauma of being fat.

The operating room was like going through the pearly gates! A brand new life awaited me on the other side. I gave my family a song by Diana Ross to play while they waited for me to come out of surgery. The lyrics were "I'm coming out, I want the world to know, I'm gonna let it show."

*Before*

*After*

To me breaking up was like waking up from a terrible nightmare, getting rid of a toothache or trading in an old broken-down Toyota for a brand new Mercedes Benz.  I didn't leave anything in that operating room that I want to go back for.  I wouldn't trade a single year of what I am now for a hundred fat ones.

I broke up with what had been the love of my life, changed my phone number, moved and didn't leave a forwarding address.  I never want to be contacted again by that old flame.  It's over—dead and gone.  I am free from my old addiction to food.  I will never be a prisoner to the desire for any type of food as long as I live!

## Chapter Nine

## *Nip It, Tuck It, Do Something With It*

Unless you have seen a person's body that has lost a lot of weight, you cannot imagine what the excess skin looks like. When I say a lot of weight I'm talking about over a hundred pounds or, as in my case, more than a hundred and sixty pounds.

Over the years as I gained weight the skin was stretched and stretched and stretched. By the time I lost all those unsightly and unwanted pounds the elasticity was gone from my skin so it hung on me like limp cloth. Obviously the skin didn't hang loose over all my body, it tightened nicely on my face and arms but around my mid-section it was unbelievable.

Ladies, I don't mean those little stretch marks most women get from pregnancy, I'm talking about big time stretching that left folds and folds of loose hanging skin on my body that looked absolutely gross.

Since my divorce from fat was complete I knew I would never need that excess skin again. I was so totally confident I would never again be overweight that I decided to have the doctor remove the surplus skin through the procedure commonly known as a "tummy tuck."

I must emphasize that no surgical procedure is without its risks but there are times when an individual has to take a chance. I heard once that even a turtle has to stick its neck out if it's going to get anywhere. I had come too far on my journey to stop before having the baggy skin removed.

What I hadn't bargained for was the pain and agony associated with the surgery. I thought they would trim off the part that didn't look good and I'd be sitting pretty. I was in for a rude awakening! I have never hurt so much in my whole life, the gut wrenching agony continued for ten to twelve weeks.

### *Abdominal Plasty*

Since I'm not a doctor I won't try to give you the medical terminology other than, the doctors

call it "**abdominal plasty**"—it should be named "**abominable plasty**!"

The doctors performed the surgery by cutting me open from one hipbone to the other in a half-moon shape, (so I can wear a bikini bathing suit and not show a scar.) Once they opened me up they pulled and tightened the abdominal muscles, almost as if they tied them all back together again. Then they stretched the skin taut, cut off what was not needed and stitched everything in place.

For the first three weeks I couldn't begin to straighten up; I sat, slept, bathed and walked bent over at the waist. I couldn't have straightened up to save my life. It was weeks before I could raise my hands above my head, even when lying in bed.

In addition to the "abominable," I mean "abdominal plasty," I had to take care of the twins. My breasts had taken a trip down south. I was so flat-chested I didn't break even with a padded bra.

I am thankful that the breast augmentation was not as painful as the abdominal plasty—that one almost did me in.

Even though mom saw how well I'd done after surgery it wasn't enough to convince her to do the same. She was scared to do it because she was fifty-nine years old. She had also battled her weight since she was a child. In addition to

being terribly overweight she also suffered with diabetes.

I made the appointment with Dr. Michael Snyder and told her to go talk to him. After an extensive examination he confirmed that she qualified for the surgery as well. At that time mom weighed two hundred and seventy-six pounds. She was one hundred and twelve pounds over what he thought she should be.

*Imogene before surgery*

Mom's next appointment was with the insurance company. Even though Dr. Snyder had prescribed the surgery the insurance company refused to cover the procedure without jumping through a hundred hoops. Even then it would only be with their own surgeons performing the radical type.

When it became evident that they were not going to cover the procedure and when Cedric knew that she would not be under Dr. Snyder's care he stepped in and paid for the surgery.

That's right my beloved husband, Cedric, paid for everything: the doctors, nurses, hospital—everything! How many sons-in-law do you know

of that would pay for their mother-in-law to have that type of surgery? It just goes to show what a wonderful person he is. He is a one-of-a-kind gentleman. I am reminded daily of how blessed I am to be married to him.

It has been more than a year since mom's surgery. She has lost ninety pounds and is still losing. It won't be too much longer until she has reached her weight goal. In addition to losing weight the week after her surgery her diabetes disappeared and has not returned.

The purpose of this book is to tell my story and hopefully inspire those who are suffering with obesity to get help before their health is ruined.

I got help as a young person; my mom got help when she was fifty-nine years old. I had already begun to experience health issues that would not have corrected themselves and mom was suffering with diabetes—the same thing that contributed to her mother's death. The health issues we once faced are now a thing of the past.

*Imogene after surgery*

I can't tell you how good it feels to get out of bed and not have to look into the mirror at a body disfigured by fat. I no longer struggle

to put on my jeans or have someone else tie my shoes. I can roll on the floor with my son. I can take him to a football game and not be uncomfortable trying to fit in the seats.

I no longer avoid the eyes of the people I meet on the street or survey a restaurant to be sure the booths are large enough for me to sit comfortably.

> *When I fly if I ask for a blanket it's because I'm chilly not because I can't fasten the seatbelt!*

My life, my marriage, my self-confidence and my emotional equilibrium are riding on the crest of a wave. My seething anger at being the laughing stock of the town is gone. I am experiencing joy I never knew possible. At last I am being received as a woman of worth not some sloppy, fat person who allowed their appetite to run amuck.

Gone are the heartsick times when I wanted to die rather than face another overweight day. Gone are the tragic thoughts that my husband deserved someone better than me because I outweighed him by more than a hundred pounds. Gone are the tear-stained pillows where I cried myself to sleep because I thought I was so unattractive. Gone forever is the self-

depreciation that bound me and held me captive with negative, destructive thoughts.

### Desire... Drive... Determination

From early childhood, through my teen years and into adulthood I battled an enemy that robbed me of life's greatest pleasures by making me crave the things I didn't need. I had no idea that living could be as wonderful and wonder-filled as it is now. All it took was desire, drive and determination!

I finally came to the point that my desire to be thin was greater than the desire for another hamburger, fries, chocolate malt and Snickers bar.

With the desire came the drive to make it happen. I realized that the fat was not going to melt away on its own. I had to do whatever it took to make it happen, which in my case was gastric bypass surgery. Dieting, fasting and going hungry had not done it in the past and for me to think it would in the future was ludicrous. And last of all I had to have the determination not to quit.

Anything worth having is worth fighting for, hurting for and paying for. I was willing to do it all! The physical pain I suffered was nothing compared to the mental anguish I endured

throughout the years. The physical pain only lasted a few days and it was gone. The mental pain took up residence and would have stayed until I died had I allowed it.

Am I glad I had the various surgeries? A thousand times YES! Knowing what I know about all the procedures would I do it again?

Despite the vomiting and nausea, despite the soreness and discomfort after the gastric bypass surgery, despite the ten to twelve weeks that I couldn't straighten up or lift my hands above my head, despite the most excruciating pain I have ever experienced I would do it again in a heartbeat!

### Would I recommend the surgery to others?

Several times I have been asked if I would recommend the surgery to others.

**Absolutely Not**!

Not unless the person is sick and tired of carrying a hundred or more extra pounds and wants to start a new style of living!

I will never recommend gastric bypass surgery to an individual who is a whiner, complainer or to anyone who wants to blame everyone: their parents, the President, their race, Sitting Bull, or the Fourth of July for their overweight condition.

This surgery is for those brave-hearted men and women who are ready to take charge of their life and make the necessary changes to begin really living. It is not for the weak-willed individual who finds excuses for the fat he or she carries around. The surgery is not for the weak-kneed, jellyfish, spineless person who is satisfied with a status-quo position in the world.

It is for those who are willing to face a little discomfort, give up their ice cream sodas, apple pie a la mode, buffet lunches, daily trips to the nearby hamburger joint and bags of their favorite candy for their midnight snack! This is for those who have enough intestinal fortitude to divorce themselves from food in order to really live.

*Let's face it, no surgery is fun!*

Fun is having your cake and eating it too. Fun is loading a baked potato with butter, sour cream and a big dipper of greasy chili. Fun is eating a whole cheesecake by yourself at one sitting. Fun is downing a bag of chips and a liter of Coke while watching a daily episode of "As the Stomach Turns;" it's devouring a giant pizza and a six-pack before halftime. But giving up these luscious fat-laden foods and a thousand more like them is NOT fun.

The question is not whether I recommend the surgery, it's whether the overweight individual is

willing and ready to make the decision to change their life or remain a prisoner to a voracious appetite.

*Terri & LéVertis*

Some will say they can't afford the surgery and that may be true! Others will find a dozen excuses for continuing to eat themselves to death.

For me the decision was simple, I would have rather been dead than to continue my life as it was. I wouldn't trade back now even if you gave me a hundred times more than the surgery cost. I have something now that money cannot buy. I have life and I'm living it to the max!

*One day of what I am now is better than ten thousand of what I was!*

Life really began when I was wheeled into the operating room; from that moment on I have had the world on a downhill pull!

Every person has to make his or her own decision. I made mine and I wouldn't go back for anything in the world.

I've been nipped and tucked and stapled shut and I've lost over a hundred and sixty pounds. My legs and feet don't groan beneath the mounds of fat. I don't have to go to Omar the tent maker for my dresses and I don't agonize over not finding clothes large enough to fit my oversized body.

For some people happiness may be Lubbock, Texas in the rearview mirror but for me it's looking to a bright and wonderful future.

## Chapter Ten

### *Waiting to Exhale*

    Had I known the joy, contentment and freedom of being thin and attractive I would have had my surgery the day I tipped the scales at two hundred and forty pounds. It would have saved me years of misery, pain and suffering!

    Freedom to one person may mean going to a smorgasbord that has unlimited refills. To another it may mean super-sizing the meal deal at Fat Eddie's Eatery or picking up a dozen donuts on the way to work and eating all of them before clocking in. Freedom is what a person makes of it.

    Freedom to me means when I wake up in the morning I can get out of bed without wondering if the side of the bed will break again under the tremendous weight. It means I can look at

myself in the mirror and not see the bulk of two and a half people.

I would like to share some of my triumphs with you. I call them triumphs because before my surgery some things were extremely difficult and others I could not do at all.

- At a recent seminar I was chosen to go to the top of the ladder because I weighed less than nine others.
- I can ride a Yamaha R-6 motorcycle. My son, LéVertis, and I enjoy riding, and I even convinced Cedric to go dirt-biking with us.
- I can tie my shoes—that may not seem like a big thing to other people but it is to me. For years I couldn't even see my feet unless I propped them up on something.
- I can go to the amusement park with my family and enjoy the rides without being squished into the seat.
- Two years ago I refused to accompany Cedric to Africa because I couldn't sit on a plane that long. This year Cedric flew us to South Africa to celebrate.
- While vacationing in Mexico a few weeks ago I was asked to be a contestant in a Bikini Contest.

- My friends call me Chocolate Barbie.
- I can walk and run up several flights of steps.
- I can now tuck my shirt in.
- I actually wear a belt.
- I finally know what it's like to buy something besides perfume in Victoria's Secret.
- I dropped the "2" in my old size 26-28. I now wear a 6-8 and sometimes a 4.
- I went snorkeling in Hawaii. I would never have done that before because I would not put on a bathing suit.
- Cedric drove me to Lovers Beach on a jet ski in Mexico the last time we were there. Both of us couldn't begin to fit on one when I weighed 300 pounds.
- I wrestle with my son, LéVertis, on the floor—something we could never do before because when I got on the floor I couldn't get up.
- I sit on my husband's lap now and he can actually breathe.
- I can cross my legs—that may not seem like much to you but it's a major accomplishment for me.

- I received a call from a friend asking me to be a model in an upcoming show for his daughter.

- I remember waking up forgetting that I didn't weigh 300 pounds anymore. I looked down and said "Hey, I'm not fat anymore."

For several years I have worked with a group of young cheerleaders on Teresa's drum and bugle corps called The Colorado Starlites. I walked with them in parades when I was fat. You can't imagine what it's like to march in a parade when you're that heavy. By the time we finished my feet and legs would be burning, as if they were on fire.

I recently accompanied them to Disney World and performed in their National Parade at 140 pounds. I even fit into one of the sixteen-year-old girl's cheerleading uniform.

*Terri with Teresa's drum and bugle corps at Disney World*

Riding motorcycles with my son and Cedric is something I could never do before because of my size. My back side was so big it would have looked like I had saddlebags on the bike. I'm sure the wheels would have rubbed or the tires would have blown out from the massive amount of weight.

Now we go out as a family and ride the dirt-bike trails. Getting rid of the fat has given me the freedom to enjoy more of the pleasures of life.

When the promoters asked me to be a contestant in the bikini contest in Mexico I did a flashback to something a man said to me at a Nugget's basketball game. Cedric and I have season tickets so we always sit in the same seats. Since we are both very out-going we have become acquainted with other ticket-holders who sit close to us.

One night during intermission one of the men asked me if I had ever been a model. We started laughing! When he inquired what was so funny we told him I used to weigh over three hundred pounds. He didn't believe us until we showed him some pictures.

A similar thing happened at a medical seminar in California. My sister Teresa showed my picture to one of the doctors. He said he wanted to meet me, so she introduced me to him. When he saw me he told us that I was not

the same person he saw in the picture. Teresa and I both tried to assure him that the picture he saw really was me.

The doctor said, "Let me see your teeth!" He looked at my teeth very closely and finally said, "The teeth are the same but nothing else is!"

That doctor was merely looking on the outside, I could have told him the internal changes were just as drastic as what he saw with his eyes. I am not the same beaten down individual that I was before the surgery. I am bubbling over with confidence. I have been given a new lease on life mentally and emotionally, as well as physically.

I can now tuck in my shirt and wear a belt. These are the type of things most people take for granted and never give a second thought.

First of all, I would have been mortified to buy a belt—I'm not certain they even make them that long—plus the fact that I didn't have a waistline. Trying to tuck in a shirt would have been an effort in futility since I couldn't reach behind my back. Besides, I looked better with the shirttail hanging out; it helped to hide some of the rolls of fat in front, back and on both sides.

When I buy clothes it's hard to believe I have dropped a full twenty sizes from what I used to be. I don't say that boastfully, rather, I say it with a very humble and thankful heart. I hated the thought of buying clothes because nothing fit right! I'm sure the clothing manufacturers

do their best, but it's difficult to make anything look good on a person as large as I was.

Aside from all the things I listed, one of the most important benefits I have received as a result of the weight loss is acceptance in the business world. I had been fat for so many years that I didn't see the terrible prejudice associated with weight.

As I became thin and attractive the prejudice was doubly accentuated. Now wherever I go men open doors for me—I promise you that never happened when I weighed three hundred pounds. Back then most men acted as if they expected me to open the door for them. At social functions men want to be attentive to my needs. Before they never looked my way, and if they did it was with eyes full of disgust. And it wasn't just the male species; all too often women were as rude as the men.

I don't say that to cast a poor reflection on anyone. We live in a society that is shallow! Every upscale magazine glamorizes beautiful women and handsome men so it's no wonder that we grow up only respecting those who look like they just stepped out of GQ or Mademoiselle.

I can tell you this; my weight loss has provided us a leg up on our competition. When Cedric and I walk into a room people sit up and take notice. We each have an air of confidence that we did not have when I was so terribly fat.

Cedric was always confident in his ability but not me! I lived under a cloud of doubt and disillusion. My new-found confidence stems from the fact that I have defeated my number one enemy. I am the winner of a lifelong battle with fat. I am triumphant in my personal life, in my marriage and in the business world.

*Cedric & Terri*

This is a book about the struggles I had with my genetic make up and the subsequent torture of being obese. I would be remiss however if I failed to give special thanks to my God for His unfailing love toward me when, by the standard of the world, I was so unlovely.

The faith that He imparted in my heart as a child sustained me through my darkest hours, and it is from His hand that I have received my greatest blessings.

I'm reminded of the words of an old hymn:

> When upon life's billows
>     you are tempest tossed,
> When you are discouraged,
>     thinking all is lost;
> Count your many blessings,
>     name them one by one;

> And it will surprise you
> what the Lord hath done!
> *"Count Your Blessings"*
> Johnson Oatman, Jr. and Edwin Excell

*What can I give in return for*
*His marvelous gifts to me?*

Three things I want to do as an expression of thanks to God and man for my exciting and marvelous new life:

First, I want to record an inspirational song in a studio that will touch those who are struggling with obesity.

Second, I want to speak out to the hurting with a message of hope. To let them know that despite their weight they are valuable human beings and they can make a difference in the world if they try.

And third, I want to do everything I possibly can to help people overcome the obstacles in life. Regardless of where they come from or what they have suffered, something good can and will happen for them.

Life is too precious to squander whether by eating or drinking too much or by any other form of self-gratification. As caretakers of our bodies we have the responsibility to feed them properly, get adequate rest, exercise regularly

and maintain a positive mental attitude.

My mission for the rest of my life is to help people of all ages and races achieve their highest goals, spiritually, physically, mentally and emotionally.

*I have learned that as I help someone up the hill, I get closer to the top myself!*

When I was fat I wanted to hide from everyone and become a recluse. Why? Because I felt totally out of step with the rest of society. I was embarrassed by my size and ashamed of the way I looked. Many times I would have gladly welcomed death.

I promise you those negative and destructive thoughts are buried with the rest of yesterday's failures. Every time someone tells me I "can't," I erase the "t" and tell myself "**I CAN!**"

I encourage you to set lofty goals for yourself and don't give up until you have achieved them. Surround yourself with individuals who will pick you up when you are down rather than leave you to wallow in self-pity.

As the old Chinese proverb says: "A thousand mile journey begins with the first step." You are capable of doing great things, so make up your mind and do it!

*If you believe you can or you can't, you are right!*
—*Henry Ford*

**May God's richest blessings rest upon you!**

—Terri

To schedule Terri to speak
at your next event call
1-800-597-8527

For more information visit
www.TerriLLipsey.com

# Photo Album

Terri at 299 lbs.

ALBUM - 1

# Terri's Childhood

2—ALBUM

# Wedding Day

ALBUM—3

# Terri's Doctors

Terri with Dr. Snyder

Before

After

Terri with Dr. Millard, (the plastic surgeon)

# Bathing Beauty

ALBUM—5

# Terri's Parents

*Imogene & Tommy*

*Terri & Mom*

*Terri & Dad*

# Teresa & Carlton

Terri & Carlton

Terri & Teresa

Teresa & Terri

## Singing the Anthem

Terri at NBA game

ALBUM—7

# The Lipsey Family —

# Cedric, Terri & LéVertis

ALBUM—9

# Motorcycle Mama

*Terri's first motorcycle*

*Maracus & Terri*

*Terri, Athena, Kimberly & Michelle*

*"Chocolate Barbie"*

10—ALBUM

Terri & LéVertis

Cyree & LéVertis

ALBUM—11

# New York

*Cedric & Terri*

*Terri*

*Carlton & Teresa*

12—ALBUM

# Hawaii

*Terri & Cedric*

*Terri*

*Carlton, Teresa, Terri & Cedric*

ALBUM—13

# Trip to Africa

*Cedric & Terri*

14—ALBUM

ALBUM 15

*A Blessed Family*